Birthday

Birthday

Dorothea Tanning

The Lapis Press

Santa Monica San Francisco

90 89 88 87 5 4 3 2

The book was designed by Jack W. Stauffacher
of The Greenwood Press, San Francisco, California.
Text type is Kis-Janson, designed by the 17th century
Hungarian, Nicholas Kis.
Digital composition by Wilsted & Taylor, Oakland, Cali-
fornia.

The Lapis Press
1850 Union Street, #466
San Francisco, CA 94123

ISBN 0-932499-15-5 *Cloth*
ISBN 0-932499-16-3 *Paper*
Library of Congress Catalog Card No. 86-81277

Contents

Author's Note

The following sample of ruminations, souvenirs, anecdotes, conversations, flights, captures, voices, and futile opinions has been written down to provide a view of an American artist who for nearly half of her life was an international one by reason of living abroad. That such a pattern of space and time is decisive in shaping late thoughts is indisputable. That it shapes the artist's inner vision and fundamental worth is of course absurd. Such a view can only apply to thirsty talents ever ready to soak up the colored inks of their peers no matter where they find them.

The other reason for the book is Max Ernst. An obsessive desire to talk of this very great man, to evoke our shared thirty-four years, to bring him into focus, to brush aside for a little the enigma that he has presented to most people, in short, to make him available and alive as I knew him to be. This, and the firm belief that only I can provide certain fundamental truths about us, have kept me happy in the telling of them.

Dorothea Tanning

I *Snow and Voices*

Every second of our lives up to then, and before that and before that too, is when we met.

The prism of consecutive events: a great day or a failed one, a leap, a bound, a stumble, a gulp of patience to survive the wait; all are dropped beans on the forest path leading back to the beginning. The moments immediately preceding our first gaze weren't really more decisive than, say, a day twenty years before when he was perhaps composing with glee and with Tzara a dada manifesto, while I in my eleven-year-old optimism was trying on a bra which, receiving nothing, was as wrinkled as a fallen parachute on the breast of the earth.

So the beginning is an impossible place, as meaningless as that dot on my drawing in a class perspective lesson, the spot in the middle of the paper where all lines—roads, streets?— came together at a place called Infinity. Only, supposing out of curiosity you tried to go there, you'd never make it. The spot would have gone, would have streaked ahead, and you would have to start all over again. It was a trick not only of the eye but of fate itself, for the point was neither beginning nor end, just a stupid black dot that would retreat endlessly.

Now on this diagram of my own devising, the lines, instead of converging, open to reveal a middle distance where we contend, Max and I, with all kinds of ardent ferment: headlong risks crowned with quiet victories; prickly defeats relieved by entrancing vistas. Making contact with great space, my antennae go wild as, later, the dazzle dims to confusion. I make excuses. And yet the confusion may be a camouflage for bounty. Maybe what is coming in these pages is not a hash but a banquet. You needn't make excuses for putting on a banquet and inviting one and all. Going to all that trouble, rummaging in the finished days, the half-nights; remembering things unclearly, looking up dates when you're not sure—was the marriage really in 1946 when I could have sworn it was in 1948—

sitting alone with only a dictionary for company when you could be at a movie, a concert, a party, or just among friends, shaking the kaleidoscope.

This is definitely not the best start. It is sullen, on the defensive. I shouldn't get so worked up. All I want to do is to share everything—fears, fantasies, fundamentals. I just don't want to forget, for example, that nest of miniature newborn mice that the housekeeper and I found behind the sack of chicken feed one day when the mistral was blowing in that faraway barnyard and which she immediately clubbed to death (was it with a hoe or perhaps it was a broom) just as if they were bugs, beetles, tiny Kafka creations, while I turned away, feeling some sort of mammalian solidarity, a kind of awed bafflement at the reality of their perfect little pink bodies, the feet too minute for my eyes to count the amazing toes. And all for nothing. NOTHING.

But no. How trivial. I want to go very deep into this maze, my life, our life, and I start talking about mice! I could as easily mention the toad we found one morning in the garden with its hands chewed off, a feline amusement surely. What a way to die. We had greeted each other every day. Our toad. Our friend, on hand, in the same place, maybe glad to see us. Until that morning on our usual round. "Don't look!" Max said, and tried to turn me away. But I saw and must forget.

That was in Huismes, France. Le Pin Perdu, our second house and second garden, a steamy green tamed by paths and without chickens, a wise geometry. No wire fence to lay down the law, no foolish barnyard creatures—those came later—with their eternal pecking, strutting, dropping, mounting, egg laying. Their glassy eyes as they sat pushing out eggs, and the shocking voices of triumph that followed. Their long afternoon ruminations, sounds more terrifying than the roar of doom, expressions of their collective boredom, sounding on the bucolic life we strove to believe in, like inane reminders of eternity, and making us wonder if urban living wasn't preferable for such as we who couldn't kill a rabbit, but did not wince too much at taking it to the butcher to do the job.

*

We will look at Sedona, Arizona, Huismes in Touraine, France, Seillans in France too, chainlinks of our years, far from New York and Paris. The innocence of country living had us in thrall: the crystal air, the charming weeds, the true mud. Even the power failures had their elegant side, with the lighting of candles and chimney lamps that were carried from room to room, pushing back the immensities that hung around the nights.

In Sedona we cooked outdoors on stones, flaying scrubby desert twigs to get a blaze. Playing house. The artist's way, he knows best, he knows the true values, the value of true mud. He can recognize poison turnip just like the friendly cowman down the road who, being a native, is authentic and wise from his leather cheeks right down to his scruffy boots and who, being a cowman could not possibly be a bore.

That was certainly a false start. It should introduce the middle distance, as promised. Mud, weeds, poison turnip indeed. Merely a dipping into an area of quagmire, one of Mother Nature's favorite haunts.

Still, it may not be all bad. Adventurous experiments need quagmires. They bubble and simmer like enzymes and make things happen. The fact is, then, if faced squarely, we are not at all pastoral, most of us mentioned here. Our beginnings are, at the very simplest, small town, more or less urban. We know fenced lawns, fresh house paint, town lanes supporting cars carrying the nondescript. So few of us ever know the true mud, the mean weeds, the furrows. But oh, how we know the collectivities.

The rural is collective too. Implacably garrulous as to voice, unashamed, in league with the maternal deity mentioned earlier. Friendly when possible. And irresistible, a magnet, a siren leading us out of towns and into vistas. So we wait, we in the city, we wait patiently until we find each other before we flee together. You do not do it alone, like Thoreau. You do not ask for that much solitude.

It is probably the tomorrow they announced yesterday. We are all on hand listening to the news. The fires, the slaughters, the economy, the coups. Discussions with the Russians. They are

never terminated, there will always be enough for the day after. Do not think too much about it, only give them a little attention, a kind of praying, like an answer to the muezzin's call with a rug-flop. So, watching the news of the world on TV is for everyone everywhere an urgent gravity, our prayer. We spin the dial instead of lighting a candle. Listening, listening, watching.

At first there was only that one picture, a self-portrait. It was a modest canvas by present-day standards. But it filled my New York studio, the apartment's back room, as if it had always been there. For one thing, it *was* the room; I had been struck, one day, by a fascinating array of doors—hall, kitchen, bathroom, studio—crowded together, soliciting my attention with their antic planes, light, shadows, imminent openings and shuttings. From there it was an easy leap to a dream of countless doors. Perhaps in a way it was a talisman for the things that were happening, an iteration of quiet event, line densities wrought in a crystal paperweight of time where nothing was expected to appear except the finished canvas and, later, a few snowflakes, for the season was Christmas 1942, and Max was my Christmas present.

It was snowing hard when he rang the doorbell. Choosing pictures for a show to be called *Thirty Women* (later *Thirty-One Women*), he was a willing emissary to the studios of a bouquet of pretty young painters who, besides being pretty, which they couldn't help, were also very serious about being artists.

"Please come in," I smiled, trying to say it as if to just anyone. He hesitated, stamping his feet on the doormat. "Oh, don't mind the wet," I added. "There are no rugs here." There wasn't much furniture either, or anything to justify the six rooms, front to back. We moved to the studio, a livelier place in any case, and there on an easel was the portrait, not quite finished. He looked while I tried not to. At last, "What do you call it?" he asked. "I really haven't a title." "Then you can call it *Birthday*." Just like that.

Something else draws his attention then, a chess photograph pinned over my drawing board. "Ah, you play chess!" He lifts the phrase like a question and then sets it down as fact, so that

my yes is no more than an echo of some distant past exchange. "Then let's have a game," pause, "that is, if you have time."

We play. It has grown dark, stopped snowing. Utter silence pervades this room. My queen has been checked twice and is in very bad posture. Finally I lose. What else could I do under the circumstances? All thoughts of defense, counterattack and general strategy are crowded off the chessboard and I see only the room with two pieces in it, my space challenged, my face burning.

There is something voluptuous, close to the bone about chess. "Your game is promising. I could come back tomorrow, give you some pointers. . . ." So the next day and the next saw us playing frantic chess. Calycine layers of an old husk, decorum, kept me sitting in the prim chair instead of starred on the bed. Until a week went by and he came to stay.

It took only a few hours for him to move in. There was no discussion. It was as if he had found a house. Yes, I think I was his house. He lived in me; he decorated me; he watched over me. From one hour to the next my plain, echoing floor-through was packed like a series of boxes so that our voices, when all the moving and hefting was done, stayed close to us as indeed they had wanted to from the beginning. I watched, in an agreeable state of mild vertigo. It was above all so natural and right, I thought; the long wait on the station platform was rewarded by the arrival of the train, as one knew it would be, sooner or later. In no time at all, the last picture found a place by the door and the last mask was hung over my desk.

That we were both painters, visionaries, did not strike me at the time as anything but the happiest of coincidences. In fact, so unbelievable it was, so touched with a kind of graceful humor, that, weighing the imponderables, I told myself, yes, if it lasts three weeks it is still all right.

A glory of pictures expanding my rooms, making other worlds out of my walls. And as if that was not enough, the Hopi idols, Northwest Coast wolf-mask, New Guinea shields. There was a totem pole that just touched the ceiling. A little dog named Katchina came and sat trembling under the potlatch that stood

between the windows. Over a door a Papuan paddle, on the desk a carved horn spoon, totem-handled. "Such an abundance!" I said. "But this was the very first piece," Max held up the spoon and told its story.

It was all about an antique shop on Third Avenue, often passed by Max who lived nearby. One day he pulled up short. There, amid a great jumble of objects, lay the Haida spoon, the four figures of its black bone totem staring from iridescent abalone eyes their superb refusal of the surrounding bric-a-brac. Max went in. From the back of the shop stepped a small, shiny man, soft-spoken but politely adamant about the spoon. "Oh, I couldn't sell it separately, it is part of the set." And Max, "What set?" "But don't you see? It is a *collection* of spoons." A second look confirmed the shopman's remarkable words. In the window, laid out in marching order, were spoons in silver, *cloisonné*, wood, ivory; Georgian spoons, Roman spoons, a baby spoon. . . . There ensued an argument like a tug of war for the goat-horn beauty (the shopkeeper thought it was seal tusk), and Max found himself talking of the great and wonderful art of the so-called primitives—British Columbian, Alaskan, Indian, Mayan, pre-Columbian—while the other listened in utter fascination, putting in a question now and then. Did those mysterious people still create such things? Alas, no, that life was disappearing fast.

In the end he sold the spoon. The buyer, leaving his phone number, said, "And I have friends who are also interested. Let me know if you get something else." It didn't take long. The next day Max answered the phone. "I'll be right over." A magnificent Eskimo mask had appeared in the shop overnight.

It was the beginning of an almost electrical streaking to Third Avenue. While the shopman's Georgian silver rather quickly disappeared he obtained, to delight the hearts of Max and his friends, ever more astonishing examples of ever rarer primitive art. Along with Max, friends Breton, Seligman, Matta, Tanguy, and Masson led the way for their new American friends. The supply seemed inexhaustible until various sleepy museums, so chock-a-block with dusty art that circulation had hitherto been difficult, began to wonder, like a man

who suddenly searches in the mirror for his fleeing hair, what was happening. But all that was to come.

Handsome. A dusty label on the top shelf where useless words are stored just in case. A word of tired approval to describe something: a gift, perhaps a gesture, a "handsome" solution. But not Max. It was disturbing as an adjective, for I did not want it, could not bear the possibility of being the less beautiful one in a bedroom situation. When he came along his looks were so tangled in my mind and eyes with all the other things he was and did, all my dreaming over his pictures before I finally met him; perhaps above all his strangeness, his not remotely fitting in with the trim thick-necked ideal of male physical splendor so unchallenged among us; so that, completely aside from the erotic matter of our coming together, I took him to my heart without one backward glance. Then when we undressed and I saw at last what I had thought to shun, a physical being all harmony, all smiles, all petal and lean muscle, and all for me, then it was too late, my dry little considerations were laid aside, and I had after all and just this once to modify my ego, without heed or head, dropping with beads and clothes the layers of protective vanity my clumsy worldliness had hitherto ordained.

Satin might describe his skin if it were not so impossible to say it. His narrow body in its economy was more like those of boys diving off the bank at the swimming hole than the curvy excrescences of Michelangelo's grown-up cherubs. Silk of hands, flowers of hands, yes, with their big fans of bones inside, strong as strong, and square. To be placed on a hip, in repose, or in pockets, as he stood one day, looking over my shoulder.

"Do you like doing that?" Under my pen dipped in India ink lay the white, Strathmore three-ply illustration board, peopled by girls and women. They were fully dressed. And the dresses and suits and coats would be bought at Macy's. Or perhaps it was beach wear. Or perfume, trailing little clouds of scent, evanescent pen lines, palely shadowed.

I put down my brush in a kind of freeze. "No, of course not.

No, I hate it." And he, "Then why do you do it?" Silently, to myself, Good God. I was embarrassed, oh worse. All this trivial activity simply revealed my fathomless insignificance and pointed a finger: How can anyone, doing *that*, pretend to be an artist? How can a true artist so stoop?

I agreed, I agreed. Writhing. But he was still there with his idle question and answer must be made somehow. So I said, "I have to earn a living."

There was a short pause. Then

"*Ecoute*," I heard him say. "I have always earned my living by my painting. I think I can do it for two." And added, unbelievably, "Besides, you are a painter. You are the painter of *Birthday*. You can't stop now." If these words had been recorded on the spot and if I had played them back a thousand times over the years, I could not remember them better than I do now.

That picture. Days later, while I show it to a would-be buyer in the afternoon light of that place, Max stands hand on hip in the doorway. He listens pleasantly until the visitor asks the price. "The picture is not for sale," says Max. A modest silence as his six words sink into two brains. "But"—and the collector looks at me— "—?—."

A brief moment of rapid phrases, high tension, a pause, I hesitate, am I dreaming, this scene from what movie? Because Max is saying quite distinctly, "I love Dorothea. I want to spend the rest of my life with her. This picture is part of that life." To this, the collector had no reply. Nor did I.

If he ventured outside of me, he knew he had not to lock the door. At these rare times we wrote letters, daily. They brought a different charm into the house, they mocked the opaque background of absence. They said things we never said out loud. How deprived are all the letterless lives today, how sad the telephone!

His letters. In them no place for revelation of past trials, no hint of his giant share of struggles, persecutions, narrow escapes; no condemnation of circumstance. As I was to learn over the ensuing years Max Ernst was as unembittered as he was undaunted. The pure inner core of him would continue to

mock the ironies while recognizing their tackinesses and their poisons.

What festooned our bower with extravagant blooms was the ongoing surrealist adventure. Twenty years old for him, new for me. A Paris blaze, its sparks had now fallen on New York to provide a little alchemical warfare. With firebrand fervor, surrealism had drafted manifestos against Franco, Mussolini, Hitler, Stalin, colonialism. These Max Ernst signed and signed again. So when in 1941, after the seizure of Paris, the invader descended to blot the sun from the southern hills of France, one knew the imperative: move on. Rumors soaked and spread. Max was wanted back there, some said, back in the fatherland, even though *Der Führer* had been photographed beside a Max Ernst painting, *La Belle Jardinière* (The Beautiful Gardener), in an exhibition of "degenerate art," and the painting ceremoniously burnt, an *auto-da-fé* complete with flashbulbs and banners. Ah yes, bring him back to the *Reich*, chastened, obedient, somebody said. No wonder then that his face was turned westward.

Meanwhile, he is in the wrong place and so, incarceration, spawn of that most dismal and most impossible of world myths, Justice, in the form of camps, followed by a thousand narrow escapes outlining his trajectory as he plunges toward the sea. One day there is Marseilles, the International Rescue Committee, Varian Fry at its helm, and a kind of reprieve. And at last he gains Lisbon, there to join those stragglers called intellectuals, saved from chaos and worse, waiting to be shipped to open-armed America, a place that would care for their beautiful brains and offer them its own treasure: a brand new way of life.

Surrealists in New York! They were welcomed everywhere. The doors of penthouse and brownstone alike were open to them, just as in old centuries the motleyed pantaloon was a must at boring princely parties. Shipwrecked surrealism. For some it was stimulation, excitement. For others, simply amusing. For yet others, absurd and "controversial"—a favorite word of the era meaning undesirable. For me it brought a kind

of relief to see my aberrant pictures find not only tolerance but enthusiasm among these seminal exotics whom I had admired for so many reasons.

To think of those early New York evenings—this is 1943—is to think of games presided over by *Le Surréalisme Même*, André Breton. The Game of Truth, The Blindfold Game, The Game of Murder, whatever the game, he led the proceedings in a manner always solemn and resolute.

Under Breton's aegis we plunged with a positively juvenile fervor into these games, which seemed so necessary to him. Had it something to do with his attention to the work of Sigmund Freud? Scratching around in the psyche? Wanting, perhaps, to make some further contribution to vital knowledge? (He did.)

He detested music but made an exception—ironic, surely—for Offenbach, the only notes he could listen to without actual distress. Yet, when he read a poem his voice was as permeated with tremolo as if it were an opera aria. I pondered this. Was it stained with musical feeling? Unconsciously? A heady thought.

Speaking only in French, this singular man was careful not to learn even three words of English for fear of dulling the edge of his own exquisite writing instrument. He was perhaps not at all convinced of proto-Indo-European roots having anything to do with French. As for English, it was simply preposterous, a doughty menace to his best possession. Wonderful it was to think of him tiptoeing around his precious language bed, administering antibiotics to keep the Americanisms at bay. If the landscape was rich in stop consonants, it was also poor in fricatives, and he secretly assured his patient that it would not be long before they were home again.

Seeing André freshly divorced, his friends were forever trying to find him a girl. One evening someone brought a pretty redhead. In vain. "I am a businesswoman," she said dryly (this makes Max laugh). "I don't drink; I don't smoke; and I don't make love." Unequivocal. Translated for André, who smiled.

He was a wizard at silent laughter. Keeping his mouth

tightly closed, his face crinkled and his soft upper body began to shake rhythmically as if he had been wound up. This was his laugh. It seemed to say: I really don't want to laugh, but I'm laughing anyway.

His ritual manner, his large impassive face masking what worlds of desperate revolt, his love of the occult, his intransigence, oh, all those things combined to present to my eyes the true *man from elsewhere*. For me no fantasist's created being from outer space could ever compare with this subtle amalgam of human sorcery.

And what of his friends? His relations with Max Ernst were a tangle of thrusts and jabs and polite smiles, of Max's grinning defiance and Breton's trembling retaliation, which took the form of frequent banishments and reconciliations.

I witnessed a sample at a New York party, one of my first evenings with Max and his friends. Suddenly everyone stopped talking, listened as Breton, facing Max, said for all to hear, "*Je n'ecrirai jamais plus un mot sur vous!*" ("I'll never write another word about you!") And Max: "*Je m'en fous,*" a strong expression, translating roughly to "I couldn't care less."

Something terrible is going on, I thought, as Breton raised one hand in a gesture to the room, his voice rising and full of disbelief. "*Il s'en fout! Il s'en fout!*"

All this time I stood there, understanding little, and aware of myself as no more than an object, blown in off the street, something or someone so extraneous and out of place that the entire absurdity of my presence there was concentrated for me in the silk flower I wore in my hair. My frivolous gesture, pinning on a silk flower at seven-thirty, showed me up, at ten, as a rank outsider. It did not, however, prevent Max from grasping my hand and pulling me with him from the room a few minutes later.

Nor did the quarrel last forever. By the time we came to Paris, five years later, all was forgotten, at least on the surface. Yet, across the years their homeric struggle deepened, with each time the spasm lasting a little longer until, one sudden day, there was nothing left to be banished from. Arp was gone, if he had ever been there; Aragon, Tzara, Eluard had long since fallen out of favor and into more dubious company

involving cards. Tanguy and Duchamp were already American, thus remote if indulgent; Miró, in Spain, deeply locked in his own universe. As for Picasso, he and surrealism were stale friends, even though he had once played its games.

Breton's answer to the truth-game question, "Have you any friends?" was, "*Non, mon ami*." As Max said, no doubt he was conscious of the beauty of this confession of absolute solitude. Friends or not friends, the dichotomy prevailed, translated into *le groupe surréaliste*.

Intellectually, they flew close to the flame. Instinctively they were far from knowing the perverse appetites they so admired and glorified, feeling rather little of fire in their loins but much of the imaginative luster. For most of them woman was a delicious mystery. These surrealist men loved to kiss her hand; they did not back her into a corner as a "sexual" fellow would have done and as some women might have liked. Of course they had their share of adventures, but they tended to prefer marriage and fidelity, endowing the simple ancient concepts with a kind of luminosity as if they had invented the former and resuscitated the latter. Given their fundamental rejection of the actual irrespirable world, procreation was considered sloppy even though a few of them had actually, albeit ruefully, become fathers and mothers. As for emulating the fantasies of de Sade's personae, they didn't even try. The games presided over by Breton flirted with daring but only in words. He threaded a swarm of projects: an ephemeris named *VVV*, an exhibition, *First Papers of Surrealism*, book display windows, manifestos. Even the diatribes were courtly and *belles* as to *lettres*.

It was all this ambivalence and contradiction that fascinated and won me. *Les surréalistes*. Although their ardor of the untried swam in an intellectual decoction of theory, philosophical inquiry leaned indeed toward eroticism, a powerful magnet along with revolt: fierce repudiation of the human condition. How strong the words of, say, Lautréamont must have echoed in their souls—"*cache-toi, guerre*"—like hot sun and wave fury that turns sharp rocks into yielding stones, round and soft. Only it was they who softened under the words. Doesn't understanding preclude violence?

I never heard them discuss the rights of either men or women. They knew, as anyone should, that a woman is profoundly distanced from a man and, moreover, quite possibly as well or better equipped to confront slippery enigmas, even to find the answers that had so far eluded him.

Woman? All they knew for sure was that they desired her. *Désir*, a gigantic five-letter word. The millions of words they lavished on her were not diagrams for her degradation. They were disguised hymns to her invincibility. I don't believe that even in the most romantic moments of literary history have writing men so adored the idea of woman. So, they felt, did de Sade. For them de Sade's message was a call to revolt, dressed in dalliance. His dry, etched prose was, for the dedicated surrealist, a program for social change that, more than a hundred years after him, they saw had not yet taken place. Far from. Also, like his, theirs was a commitment to elegance that one would call eighteenth century if, in so saying, one did not thereby invoke tarnish.

New York had no sidewalk cafés for them. Did wild ideas spurt less freely indoors? Was theirs an unease among the soft lamps, the freeform ashtrays, the foam sofa cushions of New York apartments? After the war they went back to where they came from, leaving the key on the door. Many others have used it since, but no one has brought in any new furniture.

11 *The Other Way*

Drunk with the sudden spectrum of choices fanning out before us, and moving through the city's magnitudes as in a spectral prologue played to the hilt; more absorbed than ever with the process of painting as if from now on each work would be without any doubt ineffable, for time did not so much pass as turn around us rather savagely, prompting rash, defiant spurts and somersaults, the kind of dynamic that wants only brambles and smoke to evoke Dionysus; waiting for a sort of peace to calm us in our strenuous elation and not too sure of our next move, Max and I left, nevertheless, in May 1943 for a far place vaunted by Etiemble, one of Max's fellow refugees. It was Sedona, Arizona.

At first it was to be a way to spend the summer. A landscape of such wild fantasy could not, however, be classified and forgotten when summer was over. Less than three years later we were back to stay.

There was another, and terrible, reason for the move, about which something must be said, before getting on with the glory. It began on a November New York day, or should I say a New York November day; you see, already the words are failing me, unwilling to help. They know, even if I don't, that there is no more ashen subject than physical illness, and here we are about to test the reader's patience with a (third person, please) account of the ugly, dim, hopeless gray thing that walks into smiling rooms, as it did that day, to spoil games, immobilize the dog's rainbow-colored ball in the middle of the carpet and turn Max into a tangle of helpless perplexity barely able to look unbelieving at the bed where she had been placed supine. It takes only a few hours, three in this case, to lose the use of legs when the virus decides to strike.

It had begun in Connecticut, during a weekend visit to a pretty house called Stone Legend. On Saturday, feeling odd

but eager, she tagged along to visit writer-friend and neighbor Jean Stafford. They were shown into a small library where she was all ears while the conversation about books—what else?—led to Thomas Mann, why, she cannot remember, except that Max was there, a German who was partial to brother Heinrich. They were standing before a wall of books, and to make a point, a negative one incidentally, Jean reached without the least preliminary search along the shelves and with long dedicated fingers took down the Mann volume, opened it, found the page in no time, read the passage, smartly slapped the book shut and slipped it back in its place. "There," thought Dorothea, "That will fix him." For she had never much liked him either. So she blamed her sudden dizziness on Thomas Mann. Jean was kind. "Take her home," she said firmly.

Such an indelible memory of someone, with all its attendant details of carpets and sunbeams and the golden light of an afternoon room, is often determined by momentous event, such as the sum of those ensuing hours during which two staircases were negotiated, one down, at Stone Legend, and the other up on Max's back, in New York. He runs out for help. His stricken mate crawls on her arms to open the door, a friend having come in response to frantic phone calls. A doctor was sent around; poor thing, what did he know of nature's venomous enigmas? What did anyone know? They used words: encephalitis, poly-neuritis. . . .

She said she couldn't see. She could not move. She wept, alone in her pain.

One day two white-coated medics came to take away some spinal fluid. "What will you do with that?" Max asked them. "We will inject it into a monkey" was the answer. Overhearing, she pondered the gruesome intention. Somewhere in a cage sat a silky, long-armed little fellow with his close-together blue eyes spinning bright messages to his delicate brain, his wise hands twisting and grasping the only near objects—the bars that separated him from his forest. Injecting in him the poison that laid her low, they would watch as his eyes clouded with bewilderment, as his members flagged, and as he lay, finally, racked with spasm on the floor of his cage where, when he fell, his water dish overturned, soaking the lustrous fur in a widening puddle of extreme unction.

Was all this for Dorothea? Would the death of the little monkey help her to live? Would his supreme sacrifice obtain her recovery? That he would die was certain. *But it would not be for us.*

They float up dimly, memory's negatives, *tableaux (à peine) vivants*, like worn film sequences without sound where actors play parts in a sad plan they do not understand. The days that followed were entirely concave. It was important to cling to their edges, not to slide down into the murk that lay bubbling at the vortex of each one. A noisy nurse kept her in this world though she seemed to wander in another one, all humid with gray tears that dripped from fevered lamps because no day or night lived there in the crepuscular rooms oozing their flannelette silence, broken only by the stridencies of the nurse. Men of science came and examined and went.

At night it was Max who brought the steaming towels from the kitchen to wrap around her martyred legs. Then he would sleep a little. Sometimes his young son, Jimmy, to relieve his father, sat at the bedside reading to her. There was nothing to do but wait as what are called weeks went by. At last the bellicose monster grew torpid, the pestilence subsided; the room lightened, she turned her eyes to him, focusing. That day the doctor said, "Tomorrow you will sit up."

"No, no I can't. No." She had reached that state of the sick person who no longer wants to get up, ever. Oh, the great people who have lived on their backs, their minds as far-ranging as satellites and stars!

Determined, the doctor pulled her up next day. And as quickly laid her back again, in a white faint. "You see, it is no use," she said. "No use at all." But afterward she sat and did not faint.

That evening Max brought in two glasses of champagne. They made plans. As soon as she could travel, they would go back to that place of red rocks that reared under pure blue. They would leave the treacherous city with its docked warships, its tsetse fly if he was still around, its bellowing nurse, its cold, wet streets, its improbable fire sirens, taxicabs, ambulances and knives. This time they would take everything, rolls of can-

vas, stretchers, paints. And the totem pole, the potlatch, the Kachina dolls, the pictures. They would build a little house.

Why, they said, do artists remain in cities? Must they chum with collectors, attend openings, witness name-droppings in upper east and west side pastures (Atossa, daughter of Cyrus, wife of Darius and mother of Xerxes, was a follower of Sappho) in order to make good pictures, good objects, good anything? No, we will do it the other way.

Sedona is the other way. And these are incomparable years. We build the house—of wood, for there is no water; we chase away the cattle from our five tomato plants; we haul ice twenty miles from Cottonwood. We fill our kerosene lamps to read by; we stand our ground in sudden confrontations with scorpions, centipedes, tarantulas, black widows and, in the broom closet, a snake. When electricity finally blooms, an explosion of brash white light, we are exultant and thoughtful. Our phonograph plays Stravinsky, on 78 rpm's, very loud. The sounds roll out, widen and crash against the crimson rocks. We feel certain of our fate.

The place is not a town nor yet a village. A general store dispenses beer and cattle feed, and there are lovelorn tunes in the jukebox ("That Old Black Magic"). Hear the twangy jokes of cowhands. "Hi, Max!" they say, sizing us up, taking us in, giving us the benefit of doubt. "You here to paint scenes?" Down the road is the post office, exactly eight by eight, Coke dispenser outside. Miraculously, letters sometimes arrive. . . .

All packages were irresistible to Max, rectangular surprises, wrapped and tied to be torn open and devoured. We have come down the canyon from Flagstaff and the weekly visit to the supermarket, liquor shop, Penney's, and a stop at the post office where there is a package from France. Back in our would-be driveway, we unload the heavy cartons from the car, surprises all. Even the laundry is a surprise, brought into the kitchen with the wine and groceries and immediately stripped by strong hands of its flimsy pink paper wrapping, the string broken or pulled aside to reveal the same old towels, shirts, socks Every time. As he walks away from the stupid sheets,

their faded colors, their trailing string, he just as quickly forgets his momentary deception: the laundry. It has not laid bare even one new miracle. But there are avocados and the book from France, from Paul. Open it. Astonishingly its title reads *Huit poèmes visibles* by Max Ernst and Paul Eluard. The day has, after all, delivered its surprise.

At times a word seen, *sheetrock*, and there he is, building the house, saying those words, two-by-four, sheetrock, sheetrock, and I hearing him, what does it mean, what was it for, I've forgotten, only that it was necessary to him in his concentration on the raising of the work; a house. So that thinking of temporality, of all the other things he would have been saying, elsewhere, of the things he really conjured and said and thought about; of all the other places he might have occupied, great halls and studios in a mountaintop castle, his carved ebony chair behind a vast desk, and not the shed of the Sedona Lumber Company, where he stood choosing from among the warped and knotty two-by-fours, green lumber of wartime, the fiberboard, the big nails, so that we would have the house with windows that opened and closed, where finally he could sit in the "captain's chair," like a captain of the tight unshifting little house and open a beloved book and read as if nothing had happened, as if nothing had been squandered, nothing taken away. He had simply bridged the time and the space halfway across the world where the book, or another, had opened before him, opened the dialogue. So that sheetrock never really existed, even though it breaks my heart to remember his voice saying it.

We made constant and iridescent plans, clean sprays of froth, because like surf they dissolved into airy shapes impressed on our hopes, unrealizable scenarios of an impossible future— *future*, the word he couldn't even hear without deep embarrassment and a weary disdain. Alas, it was my word.

We are all supposed to be looking into the future while keeping an eye on the present, are we not? Out here the telescope has got turned around and I see only the past, the immediate one back there, shared and tantalizing, leaking into the present which bulges clownishly, unfunny and perilous. It is here to

be negotiated, to penetrate on tiptoe and not too blindly, thus to avoid great pain. And the future? Yes, Max was right. It is an awful word.

He talks about a world I haven't known, where the tragedies have in his telling a way of wearing their masks inside out and where the most comical events do the same. Ludicrous situations, doomed group projects, explosions and fizzles like dropped stitches; artists, poets; the women, numerous, often beautiful and always at least eccentric if not unhinged.

His stories of these crazies which I must say he told with a certain relish, made me long to be mad, too. Oh, I want to be wild, I would moan. No. No. Yes, just a little crazy . . . God forbid. No. I've had enough of that. His tone was all at once serious and alarmed. But I wanted, ah, how deeply, that superb indifference to reason, to the *a fortiori* and the therefore. It was an insouciance that was never to be mine. It was a tragedy that I, foolish woman, would be spared. Knowing this, he kept me near.

Faraway events, even the smallest ones, change color in the telling. They all seemed so close there in the wide-open nights of Arizona, far from their penumbral absurdities and confusions, their dearest impossible wishes.

While our walls improvised home, the spaces around our table and our bed were hung with the web of his stories, a long strand of shimmering beads strung with knots and areas of time and place in between each one, often as not concerned with events of which he was not even a part. His own events, told in words as candid as tapestry, an extravagant weaving in colors that seemed to leap from his pictures into the rainbow of those stories where they played jokes on my credulity without, I am certain, ever telling a lie, will mostly vanish with me, a listener whose recall is far from total. Already pale, they shift in and out of focus, clinging to my suddenly opaque mind like dried mummy linen to an indistinct silhouette that, grasped, is only powdered nothingness, and where some day dedicated diggers will hack away in vain for some clue to his aura.

III *Stories for My Ears*

His fate was mixed up with exigency, an exigency utterly personal and inflexible, a demand addressed to himself *to go on from there*.

Having at the outset made some covenant with himself, or perhaps not; a covenant might have been superfluous to the chemistry, a mere foreign element that would not be absorbed into the powerful concoction, the heaven and hell of his inquiring imagination.

Instead he plunged. Down into that other element where breathing is not possible for any but a *Blind Swimmer*, a title he gave to several pictures, and a program for an artist who would rather drown than tread water, tread water.

He was as isolated as an unnamed island, unnamed because too far away from any other land mass, *out of bounds*. Determined that there shall be no unknown quantities, some intrepid bunglers try to pop him onto their maps: one of the surrealist chain that surfaced after those ugly explosions of 1914–1918, or was it before? Something about dada. The twenties. The twenties? But everything was so jolly then. Surely we know all the islands. Surely they all have names. Surely it's all made up, a *canard*, a fabrication about him and his inappropriate myth. Uncomfortable all that about his being a bird.

But there was that quick way of turning the head and, indeed, the regard from even one blue eye would have been unnerving enough. And there was his whistling, something he did only when alone or, wonderfully, with me. It was his song. "You will realize, my friend," this to me from the great Breton himself, "that he is a bird. And a cruel one. Now I have warned you."

In love, loving nature best. It was what he had counted on. There wasn't any question of betrayal with so much bounty.

Everything stayed on for him, even after hours, after days and windy years blowing the leaves apart to reveal a hundred thousand birds under spells. Stones, girls, flowers, birds, all under spells.

He was amazed by what had been attempted on him in 1914, with first his glittering youth slammed under the scratchy soldier suit and sent into the soup of mud and blood; there, on vague lost battlefronts he strove, perhaps hoping not to aim, not to fire. Certainly not to kill. So that release came, hard-won, in the form of a shell that exploded in his face. He wandered for days through wastelands and towns, wanting to rejoin his regiment for then he might find care for the wounds. "My whole face seemed to be floating." At last, at headquarters, he was sutured and bandaged.

But he was still their soldier, sound in mind and limb, equipped to do their bidding. At one point, commissioned to bring food back to the troops at the front, he rode with the treasure on slow-moving trains until one evening at a railroad station—where was it?—some beleaguered place crowded with refugees, limping, moiling human wreckage gazing at him and his Santa Claus sack, their great stares almost unseeing, in any case without hatred, for you need energy to hate. There in the station he opens the big sack and distributes the goodies. "It was like a party. The stares came alive, turned to lively glances, the children stopped crying, everybody laughed and sang and ate. It was fine, fine. I got rid of the load." "But then you were in big trouble." "Yes. Only, you see, the war ended five days later."

Time after time, bemused, ironic, secure, wanting nothing, he watched his own shadow as it fled and wandered, like that first time, as it traced what was to become the pattern of his life. Cynical he was but if you said it you were wrong. Reading and breathing and drawing he had taken measures and had weighed theories thrown out like apples for hungry schoolboys. He never said, "I believe."

How did he see himself? A beautiful boy beloved by women? Then a beautiful man loved by women? It must have

been at least a small delight for him to meet the tender talking eyes, swimming with invitation. All kinds. All his life, everywhere. To see in them the glitter of admiration, question, longing. It must have made them more beautiful, even those who were not. (How different from breathless Don Juan who endlessly pursued his cheap idea of the perfect woman, the perfect love. Poor Don Juan. Like Blunder, disconsolate on the wishing stile, he did not have the least imagination and was, even Molière said it, "a vulgar rogue, expert in lovemaking, quibbling and crime." There is no parallel here, not only because of centuries but because on Max's side radiates a constant and unassailable homage to the feminine.) Out of his own chemistry Max drew the magic formula for making women what he wanted and what they wanted to be: symbols of grace.

This is what they must have seen, too, looking into his eyes. *"La nudité de la femme est plus sage que l'enseignement du philosophe."* ("Woman's nudity is wiser than the philosopher's teachings.") Max's words.

How did he stay so blessed, so easy? How can you keep your aura and your distance in the face of constant menace, blind immensity, the overwhelm, with always a war to provide them?

I will never know much about that day in 1940 when the *gendarmes* came to his house in Saint-Martin-d'Ardèche, came for him with handcuffs. For he was still a German. Their enemy. I will never know what he said. Did he say anything? He could have laughed. This is possible. Not loud or funny but a laugh all the same. For it was an event he was ready for, had known before in parallel forms, himself the perfect blend of unfitness for the rules, the positioning of his physical entity being extravagantly out of step, his dada words out of tune. So was he to know it again and again, the long hilarious convulsion of being out of place in a derisive happening where as always and despite the exertions of the artist the rules and revolutions see eye to eye. I see them as evenly matched: the man, the sequential environments, all obdurate. Was there trauma? Not his surely. Each time, stepping over the current misunderstanding as one steps over the rubbish in the streets of the world, he

saw only his own shadow stretching before him, pointing the way.

Yet there were his wives. What of them? German, French, American, each time there must have been a decision of some kind. To be sure, it has to do with love. A sweet mirage, beckoning, leaning toward enrichment or toward perpetual adventure or toward discovery *à deux*. And surely, above all, the conviction that it can't go wrong this time.

So first he becomes the husband of Louise and father of Jimmy. The artist, the ex-student and ex-soldier is transformed into a family man, and it is like being suddenly crowned king when you had simply been out skating, say. Being a king is no laughing matter for a king must be responsible and kingly. A complicated and demanding role.

Did he fit the design? I cannot know. For it was not one of the stories for my ears, stories that made up the tapestry. Those threads were perhaps too knotted and elusive to spin out into the colored web of days and years that followed: Paris days and years populated and presided over by those outrageous shaggy monsters of nonconformism who called themselves dadaists and later surrealists, who knew the real meaning of princely fate and who, upon seeing him arrive with his box of miracle, stepped back to make way and a place for him to play another kind of role no less royal for being made of impossible ragtag revolt, for like all princes they dreamed of changing the world.

Half playing, half desperate, surrealists haunted flea markets and junk heaps for the materials of their statement. Rich in leisure if poor in pocket, they knew the power of the transforming process and even the poets wrought stunning objects made of words entwined with the city's refuse. Inspired by artists of war-demolished Germany (Arp, Schwitters in 1920) and the already magisterial Picasso, who had all known the excitement of building reliefs with found elements of wood and trash, they saw art as oracular statement made of the unexpected. They called it dada. A wrapped-in-bandage violin (Maurice Henry), a pair of siamese-joined shoes (Meret Oppenheim), Duchamp's surprises, Man Ray—the list is long.

Found objects. Irony answers the baneful. Such were the fluids in which Max Ernst breathed. To them he added his own icons and his detachment.

A borrowed passport from friend Paul Eluard had brought him across the frontier. Germany to France. Soon he had a new name, Jean Paris, for the *patron* (boss) of the factory where he painted—elephants upon bracelets, *Les Articles de Paris*. How is this done? Oh, easy. He shows me, very fast. Yes, so fast that before long his co-workers had become his enemies. He was absurd, a foreign troublemaker, *sale boche*. Besides, the *patron* was soon to abscond with all unpaid salaries.

By this time it didn't really matter. Down the sweaty stairs and into the street where his lungs swell with free foggy Paris air. Windows are on fire from the sun setting down at the end of the avenue. Rivulets from recent rain made iridescent by thoughtful dogs on and off leashes slide in between the cobblestones. Picture the café, placarded with names of beverages nobody wants. Byrrh, for instance. A word everywhere seen, a something to drink. Yet in all the years, all the cafés, I never heard anyone order it.

At a table no bigger than a serving plate, its checked cloth clamped against the breeze, he orders wine; watches absently as the glass gets a quick swipe of the *garçon*'s grayish napkin and the pale yellow stuff is dumped into it with that circular twist of the bottle so dear to stylish waiters. O accordions! O palmists, O necromancers! Up and down the street. The flea market festers near, swollen with trash.

Soon he will walk back to Paul's, walk all the way, for Paul lives in a suburb. He stays with Paul, and Paul's wife grinds her feral gaze into his eyes. So that finally Paul says, "Take her." Paul is like that, share and share alike.

Adventures *à trois* had now hopelessly smudged the memory of *à deux*. There were excursions: to the Tyrol or Honfleur, it was all the same. Paris environs in shimmering seasons, and the Americans, too, who skimmed the cream and drank wine from giddy stemware in places they had acquired for songs, always named Le Vieux Moulin: abandoned mills that no longer

turned; abject, incredibly crumbling heaps of damp stone and wood, rescued from oblivion, resuscitated with plaster and concrete—that magic spit unknown when they were built; fitted with inside toilets and refrigerators brought over at some cost and great effort from the States, and only if you knew someone in the diplomatic service.

These were expatriates, an expatriate being someone who never forgets for one instant that he is one. Some of them were still around in my time. When discussing international events, which they did with passion, they invariably said "we" in reference to what American politics were up to. I found this incongruous coming from people who were as earnestly playing at being French as Marie Antoinette played at tending sheep. Hedonists named Daphne and Nancy and Caresse, devotedly hovered by dirt-cheap *domestiques* named Delphine and Ninette and Chantal, did not lack for indigent artists and poets to decorate their weekends made of plenty of *luxe* and *volupté*, *sans* the *calme*.

He went everywhere with Paul and Paul's wife. It lasted long months during which time the burning cigarette eyes ground against him, not with him, while he made hundreds of drawings of them—did he know why?—because at last the eyes were exorcised. Not, however, before he was desperate to be free. "Why? What happened?" I ask. "She didn't want me to paint" is all he would say.

Paul too had had enough and dipping his elegant fingers into the paternal coffer—just enough, not more—he embarked for Saigon. A month later papa wired, "*Je te pardonne. Rentre.*" Exchange of telegrams, Paul, Max, Max, Paul. "Bring me my wife and I'll come home." "With pleasure." The jaded lovers then embarked too, and it was a simple matter to deliver the eyes to their mate, no hard feelings, and to wave them farewell as he stayed on to absorb alone the heady east-west concoction of Indochina.

Stepping onto the gangplank of a derelict Russian steamer for the return to France a month later, he began a voyage unmatched in farce if not in pure chaos. The boat was a "crate,"

and as if in concern for harmony, its passengers and crew might have been vying for honors in eccentricity of a particularly obtuse kind, paying little heed to the creakings and rumblings of their bark, seemingly prepared to risk all for the joyous hope of some day docking in Marseille.

Officialdom by now may have consecrated the Swiss doctor-professor of anthropology, funded on that pseudosafari by a foundation or two, who was at the time returning to his peers. But in truth he was little more than a scamp who, just before sailing, had bribed the guardian of some jungle temple to look the other way while he made off with a large, sacred snake. Why did a Swiss doctor-professor want a Buddhist snake? Back in Switzerland he would triumphantly present his find to the local zoo, after its ocean voyage in a wicker trunk. Meanwhile the deck swarmed with club members: an Association of Bereft Fiancées, banded together in pilgrimage and in a common loss; their intended grooms, French soldiers all, had perished in the Franco-Indochina war.

On the lower deck, the prim closed door of debauched Mlle Yvonne, a missionary, who lost no time in turning her cabin into a cozy opium den, frequented mainly by members of the crew. Soon something quite unexpected happened.

A few hours out of Saigon, the boat was ascream with terrified virgins, Max's words, several of whom had seen the hapless snake slither out of its hamper onto their deck. General confusion, high-pitched virago voices of wrath and terror. An hour-long search did not turn up the creature; the ladies trembled and fumed. But the unprincipled doctor-professor later learned that his dearly paid prize had gone back to its temple, by escape down a toilet and an easy swim across the bay.

Vengeful oriental gods? Malicious western poltergeists? Whatever the spirits, whatever the reasons, for three days the boat was flung against the water with sickening fury. In the Red Sea she stopped, her engines gasping for coal. Days of white suns went by in a delirium of bursting heat until, like all the other hallucinations, a rescue ship hove in sight and was unbelievably not painted on the horizon at all but a real ship

with real coal to spare. The old boat moved forward once more, its passengers waking to their destinies, emerging from the void.

Like most of the others, the lighthouse keeper was going home. Every day he paced the narrow deck, haggard though without apparent pain. He seemed not to have the power of speech. An occasional whispered *oui* or *non*. It was soon known that for fifteen years he had kept a lighthouse and, now retired, was returning to Marseille with his savings, there to buy a little house and to tend a little garden. Such was the nature of his dearest wish. Until, soon after passing the straits at Singapore, he was discovered by a copper-haired stenographer. "What kept you in Saigon?" Max asked her one day as she stood intent before the posted passenger list. "My work." "?" "Yes. Import-export."

She had her place changed to a table for two in the dining room, just she and the lighthouse keeper. "What kept you in that lighthouse?" she asked him. "It was a trust. You see . . ." he murmured. He told her all. Soon they were leaning together hand in hand gazing at the pewter ocean, hands under the table in the sweltering dining room, hand in hand late at night on the deck. And thus a romance grew bold on board, how nice. In the souks of Colombo, he bought her large precious stones.

On the dock at last in Marseille, everyone came alive; porters tussled with trunks, and people behind the barriers screamed exaggerated greetings. A figure detached itself from the bustle on the quay, moving faster than the others, running in fact, arms aloft, turning and running back in zigzags through the crowds. It was the lighthouse keeper. "I almost didn't recognize him," says Max, "he talked so fast: 'Where is she, where did she go . . . I can't understand, have you seen her, have you seen . . .' I couldn't do anything for him. What was there to do? She had vanished." As the man stood there in shock holding his head, he visibly diminished, as incorporeal as a transparent lighthouse window giving onto an infinitely rolling sea.

He turned then to a *gendarme* and politely asked the directions to *Les Offices Maritimes*. His money gone, he would of course sign up again, another lighthouse. What else is there? And in fifteen years . . . "they will pass . . . they can't last forever," he whispers. "*Au revoir*." "And as he tottered away," recalls Max, "I called idiotically, '*Bonne chance*.'" The ashy taste of those two outrageous words.

Marie too, became a wife. She was scarcely eighteen and dazzled everyone, even surrealists, with her blue and gold porcelain beauty. And Max dazzled her. They ran away together. So that the bitter objections of her infuriated parents were too late to repair the damage. Seething, they had, *bon gré mal gré*, to take him in, more as a fresh closet skeleton than as a son-in-law. But more of them in a moment. Meanwhile it can be stated that the girl though in love seemed elsewhere and not a little strange.

Not Max. Encouraged by the way all the gaily colored threads were weaving the spiral of his artist-life, he painted and pasted and wrought fast-drying plaster; he thus drew the shape of his thought into a monument marking his victory over dreary adversity. The studio in the rue des Plantes, time to paint, the friendly collectors who left with pictures under their arms, the plash of glinting surrealist voices at the favorite café, the beauteous wife. Only it was sometimes disconcerting the way a new painting would disappear. On these days she would come in toward evening with her hair elaborately curled, her nails pointed and painted. The little pictures paid the *coiffeur*, as it turned out; was it not lucky that he liked them?

Perhaps it was, if that had been all. But there began a hazy series of retreats into the sickly past, a pattern but dimly comprehended by the bewildered husband who fought a losing battle with uncomfortable evidence. For behind the pretty face was a victim, all warp and no woof, fashioned to conform to their insane caprice by a pair of lunatics who happened to be her parents. Indeed, outlandish as it may seem, all her young life the girl had been groomed for sovereignty. Incredulous

Max heard her tell of the legend—oh, but it was true!—that she was destined to be the queen of France. Yes, a letter was lying in a secret place (where?). It was written by Mme de M.; it had waited a hundred and forty years already; it traced the lineage in no uncertain terms, there was no doubt, no doubt at all that Mme A. herself was in direct line and that her daughter would ascend the three velvet steps to the throne when the moment came. The letter was to be opened (a day was mentioned) and she would be crowned queen. The monarchy finally restored, she would be *Sa Majesté Marie*.

At first he laughed, hugely. "And me, then what would I be—the prince consort?" He was all amused indulgence. "*Je suppose*," she answered absently, dreaming perhaps of what *équipage* she would choose for her ride from the rue des Plantes to the Louvre.

They sent her as a child to a "very exclusive" *pensionnat* on the isle of Jersey—only girls of noble birth were accepted. In this school presided over by nuns who were of course equally noble, Marie, the little *roturière*, was scorned and snubbed unmercifully by her playmates until one day the entire school body was summoned to hear an announcement. The mother superior swept to the podium: "There is, among you, a *pensionnaire* who may seem undistinguished in your eyes and worthy of only the merest consideration. By these words, my esteemed girls, I now tell you that the person in question is of the noblest lineage possible and that she is destined to rule over you all as the future queen. You will now return to your rooms to ponder these words and to make the adjustment in your minds that such an announcement demands."

In the rue des Plantes, 1927, the famous letter was somehow forgotten. But its effects hung around the studio like noxious fumes from a nepenthean admixture designed to keep the world at bay. In some incomprehensible way the spiral was upending, turning into a tunnel. There were, to be sure, fine moments with surrealist friends who, at the peak of their powers and their conquest of large chunks of the knowable present, counted the beautiful couple as a living proof of the positive ethos. Too, there were invitations to the opulent tables of

what is still called *le tout Paris*, where the dishes were often so-so but richly composed, invariably satisfying the lusty appetites of poet and painter alike.

If life in the rue des Plantes was not particularly stringent, Marie proved otherwise, and her religious fervor spilled and soaked into every corner, spreading thus an odor of sanctity that pervaded even the conjugal bed and so rendered lovemaking a sorry exercise, not only joyless but somehow unseemly. For the abiding shape of her every action and the color of her every thought were formed and tinged by a medieval fanaticism ever more melancholy and soul-deforming. The lifelong prop of her royal destiny having evaporated like holy water left in the sun, she threw herself into a blaze of self-castigation: She was *immonde*. She was abject, a sinner. Like a tormented witch she flung their hard-won pennies into the cathedral cauldron and raised her voice in public confession.

While Marie's afternoons were a steaming broth of orgasmic devotion flavored with *coiffeur* philosophy, his own passed in the blissful pursuit of his personal chimera. But there wasn't enough money, sometimes not quite enough food.

It happened once or twice that Amal, their Senegalese friend, blew in at such a dire moment. He too had not a sou. But, "*Attends-moi, je ferais le boulevard*." And an hour later he was back with bags of groceries and wine, his wonderful white teeth triumphantly bared in a beatific grin. Saving the day but not the morrow.

Scolded about the purloined pictures and not being able to contemplate a future *sans coiffure*, Marie cast about and found a job. It was during one of those *mondaine* luncheons that Schiaparelli, the great *couturière* of the place Vendôme, sizing up the girl's face and figure, said she could use a receptionist. So began a specious interval, specious because, though the work was amusing, more or less, it did not last long. In fact after only a few days it was all over. Her mate did not know what had happened, why she didn't go back. Probably he did not want to know. It wasn't mentioned. Until a friend brought it out to him: Madame S. was not pleased about the way Marie had sat in the window (she had to mind the salon during the

long lunch hour) painting her toes. One morning Max asked her if it was true, and she said yes, it had been very peaceful.

From then on there was no talk of employment, a demeaning word in any event. And soon it was clear that even an errand could not be undertaken. Once in the street the wretched girl would give the money she carried to the first beggar encountered, if he would pray with her.

It happened that a portrait, commissioned and paid for in advance after a discreet glance by model and husband around the bare studio, was to be delivered by Marie. Max, hearing no praise, assumed it wasn't too successful. The lady sitter, not seeing it appear, assumed the artist had his reasons. Until one day, twenty years later and passing a Parisian framer's dusty window, she saw her own eyes looking out from a heap of frames in the corner. The eyes were waiting to be claimed if one paid for the frame, said the old framer. Politely, no one had ever mentioned the absent portrait to the other, though artist and model met rather often after those hectic times.

Drift and dust blew everywhere by now. The studio was an island or a cell, it didn't matter as long as brushes and colors were there, furnished gratis by a generous merchant—all he took was a picture now and then.

A word about the Lefebvre-Foinet family, purveyors of artists' materials, French and traditional to the bone, monumentally dedicated to the users of their (handground) colors, their (handsized) canvases, even handmade papers, Russian sable brushes, little tin pots to clip onto the edge of palettes, oh, let us just say the things that artists do not use anymore.

In their resin-colored, oaken-lined shop, behind a window full of immense jars of paintbrushes and one of those energetic jointed wooden robotlike dolls that are fondly supposed to help beginners learn figure drawing, and issuing from the shadowy back room where packages were made of unpackageable bulks, and from his pocket-sized adjoining office hung with tiny pictures, would appear Monsieur Maurice Lefebvre-Foinet himself, full of *bonhomie* for the gents and gallantry for the ladies.

Monsieur Maurice never failed to make this distinction no matter what kind of a painter you were, and his smile was shed

upon you in direct or oblique rays according to your gender. One imagines that in earlier days female customers were rare indeed, unless one counted the probably silent, tousled, model-companion who would appear, huddled shyly against her blustering *maître* as he chose his tube of raw sienna and muttered something about putting it on the tab before lumbering out in the cold, his pink-nosed girl close in his wake like the *cache-col* wound twice round his neck and fluttering in the raw wind. To all of them the shop dispensed warmth and encouragement along with brushes and tubes of paint. The all-too-often indigent artist knew that there he would find credit, in exchange for an occasional work from his hand. To this day, hundreds and hundreds of pictures (some of them ours) stacked against the top-floor walls of their ship's-prow-shaped house bear dates from the grandfather's time. And sometimes there is even something beautiful.

At one point an invitation came for Max from London, a good gallery, friends of friends, would he like to show? It was full of promise. He prepared, pictures were sent, tickets bought for the boat-train. When the time came to leave, Marie would not go. She was ill. She was unworthy, unclean. She was adamant. He was obliged to go alone.

Arriving in London he found a telegram from her, "Please." So tickets were sent (it would have been folly to send money) and careful instructions added as you would for a child with her name pinned to her coat. They waited, he and friend Roland, at Victoria Station. The train came in and stopped, sputtered and released a cloud of steam while Max and Roland scanned the passengers looming out of the cottony stuff like hurried phantoms. But no Marie.

As they stood there, Roland was saying that she just might have missed the boat-train. Even the steam had blown away to reveal on the platform a solitary porter struggling with a trunk that had lost its handles. Beyond him, from far down the platform, a miniature female figure drew closer and they wondered aloud, could it be . . . ?

It was. Advancing slowly up the platform, not smiling, not running, and with a slight limp. Marie.

In filthy rags and lace, ancient rubber shoes, her white face

drawn, eyes like craters, she carried a wilted bunch of violets in one hand, a string bag in the other. That there was nothing at all in the string bag probably seemed to these two baffled males an appropriate detail of her apparition. There she was, all drained and hollow, one of those people whose role it is to dampen high spirits in others.

Roland balanced on his heels and smiled uncertainly. Max stood embarrassed. Their banter tarried, their grinning faces sobered like those of scolded schoolboys. Roland hailed a cab and, flanking her tenderly, they swooped down to push her in. "You are so kind, so kind. I don't deserve it." "Shhhh. . . ." "Ah, but it's true. . . ." By this time there was no trace of intimacy in her voice, only the litany of her sinfulness, her uncleanliness, as she kissed his hands or knelt down. For two days they reasoned with her: "Please forget all that, darling. You're a good girl, you must be nice for Max. Come now, we must get you some clothes for the *vernissage*." And Roland brought her to a dressmaker where she gazed at the models swinging and twirling, gazed sadly, hunched in the borrowed coat, and murmured her broken-record obsession: "Unclean, unclean . . . why bring me here . . . I am filthy, a whited sepulcher . . . the holy Virgin knows, she understands . . ." and then dully, "Take me back, take me back. . . ."

They questioned, they reasoned.

It was, finally, impossible for them to find the slightest cause for her self-abhorrence. Sin was as real in thought as in deed for such as she—thus it is perfectly fascinating to contemplate what were surely ravening inventions of her mind.

Back in Paris her closest friends were converts to the faith— perfervid zealots whose piety, as is often the case with this very strange category of human wreckage, far outstripped that of the tepid, born *habitués* of the confessional. Except for Marie. For her and her suite the confessional was a tingling bath of fire and flogging, as frequent, as intoxicating, as irresistible as is the local *bistro* with its *coup de rouge* to the alcoholic. They approached the baring of their souls with eager step on the cold flagstones of churches and cathedrals alike, all with their booths of wild sorrow behind sin-stained wood.

Here in London confession was problematic. Catholic

churches were few. And in what words could one cry out? The hour of the *vernissage* arrived. She would not go. "Leave me here in my room." She would meditate, she would pray. But when they returned from the gallery she was not there.

The night passed without a sign, and, fevered by exhaustion, Max slept. At dawn the doorbell brought Roland down the stairs. Marie was there on the curb with the taxi driver who demanded his fistful of guineas. They brought her inside. She had found her way to a priest far out of London, a French Catholic priest who had accepted to hear her urgent confession. Mercifully she then slept for two days.

In the London week that followed, while he kept appointments, was interviewed and invited, Marie was losing all contact with the real world. And still there was no one willing to lead her away. She was so pretty. . . .

The breaking point loomed and advanced, with its seductive promise of oblivion. Foundering, the artist breathed heavily and without joy until, one rainy day, Marie, drained and absent, asked to be taken to the boat-train for Paris. So once again Max was at Victoria Station. He saw her into a compartment. Farewell. For they both knew that her departure from London was the departure from his life.

Firmly identifying with his pictures, with *Loplop*, *Bird Superior*, and knowing that all nightmares come to an end when night backs away, he stayed on, attentive to his exhibitions and to the picture that was London 1937.

Looking up from a dinner plate one evening, he saw his dazzling reward—English this time, a Leonora undaunted by imminent breaking points, seductive though they might be. Menaces are made to be foiled. And so they carried each other off. And landed in a high windy house in the south of France. The town? Saint-Martin-d'Ardèche, where olives grow and the mistral blows your past away.

I could not pretend to know anything of that time except for the mute testimony of myriad creatures in cement and paint and iron that he left there forever and for all to see. And a few more stories. They have to do with vineyards, dogs that ate grapes, and the denizens of the local bar. There was a rotund,

elderly *curé*, a kind of abbot I think Max said, in a neighboring village, one of those places that lie upon the earth just as they did in their prehistory, the hills and stones undisturbed by frenzied stabs at modernization, their inhabitants as rooted as old trees. This ecclesiastic was their protector in the eyes of God and they tolerated him as such. His only fun was an occasional visit by donkey-back to Saint-Martin, the big town for him, where in the café he could forget his savage flock and exchange words with several sophisticated philosophers: the barman, the wine grower, the olive pressers, the village bum.

Sometimes Max was there and a kind of friendship sprang up between artist and divine that resulted in an invitation to dinner by the genial *curé* who assured his friend that cooking was his hobby. The day came, the artist came, the five-course dinner came to the table in all its glory. "*Bon appétit*," smacked the host as he dipped a spoon in the sepia soup. It was indeed a spread, copiously *arrosé* with superb wines and a special cognac as tailpiece. What intrigued the guest was the satin-smooth way the same plates were replaced by his host, padding from kitchen to table with that buoyant, almost levitational ease fat priests have in their cassocks as they imitate old sailing vessels complete with slanting tack and full furl. Especially admirable, he thought, must be the discretion of the woman in the kitchen who never once showed her face. And for reason. Because, strolling in at the end of the repast, as if to take a bow, and licking his chops, was the *curé*'s faithful helper, his dog. He it was, together with the roly-poly man of God, who cleaned the plates between courses. How else, said the man simply, could he do it all alone?

Un peu de calme, a little calm, *A Moment of Calm*. It isn't hard to imagine that calm, tanned and fanned by the hot Provençal wind, careless as the cicada. Indeed, the calm flowed down the hill from the stony house with its crazy beckoning sculptures and friezes, a whole population of chimeras and prodigies in cement, not salt, and from the light in a makeshift studio where he stood immersed in his phantasmal world, master of canvases redolent of bog and swamp and rotting forest, lush triumphs of his brush.

It was 1939, spring calm, a precarious calm and so much more precious than any old calm. It was a drop of dew, a perfect world sliding slowly down a leaf and hanging there for dear life, a golden life with a beautiful companion, only a little mad if you were careful. So in that lull he painted the big canvas and glued it onto the far arched wall of the garden room, open-ended to the winds.

Here was a sad, spiny forest hiding the specter of war, for he would not summon the brutality to bring doom out into the open, though he knew the smell of blackened leaves from long years before. So he knew there was no life in the spiked, tangly trees. Where were the green veins; where the swarming life of *La joie de vivre* of 1936; where were the caterpillars, walking sticks, the mimetic jokes, the wood-lice, moths? Where were the birds? Instead, the iron branches. Motion was laid and the drop of water hung. The picture was an omen, not a warning. With eyes wide open but not blazing he mutely saw and mutely recorded. There in the high house with its olive groves and its grapes, a place that to this day wears the raiment of its reliefs, its sculptured phoenixes, its frescoes, he stained the wide canvas in blackened green and blue and rust, uneasy colors of fading hope. Thus ravished, the rectangle gasped and held its breath. He called it *Un peu de calme, A Moment of Calm*; for he knew it was only a moment, this calm, and that the storm was eyeing him from the north.

Until that day when they came with handcuffs and led him away, he, the enemy alien. The storm was no longer far away and the calm had been, indeed, a moment.

Such was the way the dewdrop life slid and fell, crashing like a fragmentation bomb around the bereft companion who sank gently into a cognac oblivion supplied by the local innkeeper who would afterwards take the house in payment for the booze.

He is an enterprising man. He will turn the place into a bordello for the customers from Avignon, the big town, a hideaway from wives and spies. Meanwhile he lets her stay, alone in the house, when along comes a compatriot from England who, taking charge, will lead away her friend, away from this

grubby farm, away from nasty France. Listen to her as she paints a screaming picture of rape rape rape that is sure to arrive with the Nazi advance.

Packing in haste, just time for a note: "Dear Max, I have gone with C. and will wait for you in Estramadura. . . ."

Off they fled, across France and Spain. But the sorely tried girl shattered like a mirror along the way and was taken to stay in a Santander clinic.

For the third time he escapes from the camp (Largentière? Loriol?) to find his way home once more. She is gone. The house is not his. There are heavy men sitting around the table in his kitchen. Each one of them has a fifth finger missing (a precaution against conscription). They are genial in the main, why indeed not, since they don't have to go to war! They are even sorry for the poor *boche* who has not been very clever. He is allowed to stay, an overnight guest as it were.

Because next day the *gendarmes* are back, embarrassed about the handcuffs. "*Allons, Monsieur Max, sois gentil. Faut pas faire ça. . . .*"

And the horror goes on, hilarious. Another camp, Les Milles this time, a former brick factory. The ovens make splendid cells, full to bursting. A motley population: legionnaires wearing chestfuls of medals; traffickers in everything from cigarettes to opium (indifferent grade), wine to *foie gras*. Bellmer in the same oven draws Max in profile, his fellow artist and all made of bricks, a brick profile from the brickmaking oven. And behold the splendid *commandant* who, approaching the artist politely but firmly, would have him make the portrait of the camp, of which he is proud. (In fact, twenty-four years afterward a letter arrives from the old bastard. He is still alive out there. He had heard of the artist, his former internee who so ably painted the portrait of the camp. Would he mind signing the picture?)

There was a nightclub run by the plucky pansies; their loves and losses provided blessed distraction from the bricks. While they sang and played and swished their ruffles, the digging went on dogged and hopeless, in the brick cell walls, slyly watched by the guards before their triumphant ripe moment

of discovery; so that the diggers, thin, blinded rodents by this time, could begin again the only thing that by now they knew how to do.

It was dark in the brick oven. Drawing was harder than digging, but then, you see, you were *required* to draw. They wanted their portraits, the vain posturing officers of Les Milles, for after all, who is not intrigued to see himself on paper instead of in the spiteful mirror.

As a reward for the portraits Max was assigned a flattering task: to wheel out the garbage beyond the gates. A promotion, really. A distinction nicely concomitant with his talent, you might say if you were an officer in charge of the mangy prisoners at Les Milles, France. You might also say, if you were the trusty in charge of garbage, that such a distinction implies, even demands, one thing: escape. So he took to the road again, this time with a poet cellmate who, as it turned out, could not swim and so became a drag, an abject, jittery lump to be carried across streams, to be hidden from beady-eyed *paysans* who, seeing him, would read the story without the least help from words.

Back to the high, empty house, a silent evening errand this time, a lightning visit, to remove his pictures, oh, some of them, from their stretchers; only the smaller ones, to be sure, to roll them in newspapers, anything. Goodbye, goodbye to the warm wind, the olives, the wine. Goodbye to the calm that was. For now he will not come back.

See him running across the hills, hiding in barns, avoiding the roads, the towns. Bridges are the worst. A bridge is guarded at both ends. The sleepy peasant lets him hold the reins; the sleepy horse pulls him across. Just twenty more kilometers to B. de L., *sous-préfet*. My old friend will help, will give me an exit visa. But Monsieur de L. was not there, they said. No. But there is Georges, *préfet* of a neighbor *département* perhaps sitting in his castle, for it would be hard to imagine him leaving it for anything so ephemeral as Nazis. On to *chez* Georges. What is fifty kilometers?

Georges was there and went to his library to write out an

exit visa, an impressive piece of paper that he hugely enjoyed decorating with his illegible signature and every last rubber stamp on his desk. There followed a hundred and one more escapes, a thousand ironies. At last the frontier, the station and a train for Madrid.

The border guard is full of zeal. He studies the pretty stamps while Max breathes, an eternity of careful breathing. He looks up.

"This is a very strange exit visa. I have never seen an exit visa like it." He is called to another desk and comes back frowning, "I'm sorry. I will have to send you back to the prefecture in Pau."

At the same time another uniform, a customs inspector, barks: "What have you got wrapped up in that paper there?"

So took place the exhibition of his life, with the unrolling of those wild and sumptuous canvases that in what seemed like a few minutes got tacked to peeling walls of the dreary little station. Travelers looked and marveled.

There before them were the forests and their glistening basilisks, the green eyes of rampant nature that stared down the officious customs inspector; the totem excrescences that spoke urgently to the fluttering nuns with their clasped hands and murmured, *"Bonito, bonito,"* the bursts of iridescent life that mocked and wooed the border guard.

He gazes, walks away and back again. In the general commotion he has made a decision. He plants himself before Max and his voice must have trembled slightly: *"Monsieur, j'adore le talent. Vous avez un grand talent. Mais je dois vous envoyer à Pau. Voilà la direction pour Pau. Voilà à gauche le train pour Madrid. Voici votre passeport. Ne vous trompez pas de train."*

("Monsieur, I adore talent. You have a great talent. But I must send you back to Pau. There is the train for Pau. Here on the left is the train for Madrid. Here is your passport. *Don't take the wrong train.*")

"Adieu, Monsieur." Wouldn't he like a souvenir, a little picture? He did not hesitate in his gruff murmur, *"Non, merci."*

From the train window glazed eyes look out on glittering Spanish hills. At towns thin, wiry boys crawl over the cars.

Great moist eyes and thrust-out hands seem to be everywhere. Plagues of boys that fall away when the train picks up speed.

Then one day there is Lisbon, and Estoril, where the hapless refugees wait for papers with rubber stamps. For weeks, months. There too is Peggy Guggenheim, the gentle collector of painting who will effect a rescue, will bring him to America. Here during a few bewildering days on Ellis Island (July 1941) he enjoys "delicious hamburgers and a splendid view of the Statue of Liberty." Then, with son Jimmy and Peggy Guggenheim as guarantors, he is freed.

IV *And for His*

When it was my turn to talk, what could I tell, what was there in my childhood to compare with storybook Rhineland and little Max in his nightie looking for the railroad tracks and falling in with a procession of fanatics who called him baby Jesus. His father, a devout Catholic and a weekend painter, was impressed, even exalted; so that, carried away, he then painted his boy as the Christ child, thus incidentally compromising his own chances for heaven.

How could Galesburg, Illinois, a place where you sat on the davenport and waited to grow up, compare with Cologne: its mighty cathedral, its stained glass lambencies that fell about children's shoulders like jeweled capes and turned them into princes and poets.

My early memories surfaced, wavered through time, riled the stream—bloated forgotten fantasies rising in murky fluids. But almost always the wrong ones. I fished for vital statistics; even decisive events eluded me like soap in the bathwater.

I was born, yes, and ran fast but never away. Then and gradually, under the same blanket sky as Max's, I strove and fended and believed that my star was as free as anyone's on earth. Soon I was hung about with intricate ears and shoulders and round arms and breasts as diffidently worn as the ones in those museum pictures beside which little white cards inform the visitor, erotic—all-powerful buzzword applied according to the amount of female flesh on view (male derma does not seem to rate this qualification). That was me, who rather liked it all, not recognizing the affable enemy of headlong females and tiny stars. That was me, high flyer, skimming forbidden ground. My enemy? No name, no face, but alive behind every manmade facade, a condition only, but invincible in its raw supremacy. To ignore, I said. Keep flying. Steer clear of sig-

nals, roadblocks, towers. And now, wise or foolish, I have landed.

To this beloved face I cannot accuse. He is mine and I am his and the enemy is elsewhere. Here I confide my tangly self, the oceanography of lost heartbeats and submerged hopes dredged up from the dimmest deeps, brushed and cleaned of their barnacles, offering its trivia to Max who says, as always, "And then what?"

Now the water is still and I see the shape of a summer day in 1922.

Outside the Orpheum Theatre in Galesburg everything glares so that the street and shops seem to be simmering in a desert hallucination, a mirage without the sand in it. My father and I are out together in the blistering afternoon to see a movie. No one else would go. Cowboy! Family scorn, unanimous, sends my father on his way, if he really insists on it. But I'll go. In my white shoes and organdy dress. Downtown, heat flings up a shimmering veil from the pavement bubbles and our heels indent its black tar like miniature horseshoes.

My father wears a panama hat and buys two tickets at the window, one for him and a half-one for me. And I remember my sister that morning: "Who wants to see Tom Mix?"

And indeed who does? Certainly not my father who is there for the horse, Tony, not for the rider. Horse crazy, my father. Tom Mix is nothing to me either. I might as well have stayed up in my tree fork where, nailed to the big branch in front of my seat is a box with key and tin lid. It is for secret formulas that have nothing to do with the movies.

I begin to regret . . . but in the dark someone smiles at me from the screen: Lord Churlton. Blue moonlight shows me a careless leg encased in close breeches and sensuously cuffed boot. It swings over a windowsill. In a trice it has been followed by a head, arms and torso, all under plumed velvet hat, lace collar, doublet, gloves, rapier and great hints of fine linen on pulsing muscles. Two cruel black eyes burn into mine. And while my father thrills to the clever Tony, I am lusting after Lord Churlton, the villain. Never mind the secret formulas in the tree box. There is a time for everything. And you, Churl-

ton, never mind that simpering lady with her careful curls and swelling bosom. Leave her to Tom Mix and come to me. I am waiting, waiting, you are a beautiful villain, what is a villain, what is evil, O passionate Lord Churlton!

I tried to draw him that evening. Not in his ruffled shirt and velvet redingote or yet as Adam, but standing in a doorway and wearing red-striped pajamas. As the fabric and tanned cheeks had to be colored, out came my box of watercolors, two rows of tiny round pans of faintly colored cement (it tinted rather than colored) accompanied by a pointless brush resembling a glue applicator. The likeness was poor, but then, who could do justice to Lord Churlton? I dreamed of him coming to Galesburg, even as I knew that he would not.

"And then what?" Max wants to know.

My father's name was Andrew (or Andreas, back there where he came from) Peter George Thaning. A rag of old-world pride made him try to interest his children in the "family book," a compendium of names with titles, professions, deaths, births and marriages—the usual. Self-exiled, a dropout, a runaway from Sweden at age seventeen; it was now all he had left, the precious book about faraway people become as legendary as Arthur's Round Table, the big comfortable house back there now became a castle, the grain fields an enchanted wood, the ribbon of ice an endless river upon which a little boy skates home fast with the breath of wolves on his neck.

One of his two cardboard concepts, nobility, was not a quality but a class, to which he thought he belonged. Were these pretensions? He slowly died of them, no matter what the newspaper said, no matter how my mother deplored his hiking, running, swimming. "Lying in that lake for hours!" Because the other cardboard concept was physical splendor. And strenuous sports never end for people who aren't going to die anyway.

He admired Hitler because of the sports. We listened to the news from remote stadiums: Olympic records being broken as

crowds went wild. We listened to the funny new rhythm of marching feet that got mixed up like static in our radio, stronger and stronger. Then Hitler started killing people. And that is what really killed my father. Shattered by deception, his heart stopped beating about the time Hitler was marching up the Champs-Elysées.

"And then?" says Max, wanting nothing left out.
 Oh, Max, what's the use?

Only a hopeless romantic could like getting off a train at our town, could think that stepping down onto the platform of Galesburg's depot was part of an adventure worth living, something to be savored and treasured and maybe used afterwards in some made-up form or other. Of course you identify with it if you have been there when it was very small, you and it, before you went away. But how could my college days there compare with Max's student capers around raging bonfires on the banks of the Rhine, where philosophical parlance blended so strenuously with Lorelei sirens? Could I imagine there was anything amusing about my buying a pair of satin slippers one size too small because it was the only pair in town, and about the indescribable agony of wearing them to the prom? The bright remarks I had prepared for the ears of hard-to-get boys burned to ashes in what seemed a direct electrical contact with my feet, before they had time to get uttered, irretrievable victims of vanity.

Max listens gravely. "How awful," he says. "And what then?"

If there was anything at all that troubled my certain destiny as a painter, it was the Galesburg Public Library, looming large, massive symbol of pure choice. Imagine a wide gray stone building of vaguely classical design and chunky proportions. It sat in the very center of town, in a modest island of grass surrounded by barberry bushes. On the next corner the post office and, a few blocks away, the college that tried to teach me something, anything.

For like all nice girls I went to college. Unlike most of them I did not select a fellow undergraduate to marry as had been hoped. I had other plans, not well-received at home. In fact the very mention of *artist* was synonymous with *bohemian*. Art school is not a *school*. The girl is all turned around. College will straighten her out, will soften harsh lines, will calm the wayward, spinning colors, the oddness, the fever. How needless my parents' worries about the bohemian life I was headed for. They would have solidly approved, poor things, the big city art world, a kind of club based on good behavior and a certain tactical chic involving doing the right thing at the right time.

Every time I passed the Galesburg Public Library I would see myself hidden in the stacks, making the kinds of discoveries that were not likely to be made at my college. This would soon happen, in fact. For at age sixteen I was employed there, part-time it is true, but the employment provided a certain illusion of independence and even included a vacation—one that took the form of a rented cabin at Lake Bracken, a sort of sprawling country club, my earned money would pay for two weeks. Alone. Self-consciously, uncompromisingly alone. No to sisters. No to friends. No to boys. No, no. Instead, the clean ritual of laying out paper, pencils, crayons, watercolors, the usual stuff, on the deal (ah, the simple word!) table. Something would happen, had to happen. It filled me up and down, back to front, and my head said that it would spill out cornucopiately onto the deal table. This two-week evasion, bought with the ugly money I had earned drably, would produce: flowers or monsters, I didn't care which, for they would be mine. Sometimes I stared for hours at the very white paper.

Beyond the screens of the porch, mosquitoes and lake danced and rippled, respectively, under moon and sun (for there was a moon, I had planned for that), and inside the musty little cabin four camp beds sagged, all empty and uncovered but one; the pallid cushions, pancake flat, exhausted, unable to sit up straight; the deal table. I had dragged it to the screened porch, such a reasonable place for a worktable in July. Reasonable, too, to go to bed early after an interminable day, for this would certainly bring on tomorrow, a better event in all its glow and promise.

Sweaters and raincoat covered my blankets at night for it was cool and often rained.

There were visits, just three. My sisters came out and looked at me. Baffled, hurt. They brought a pecan pie that sat on the drainboard, wrapped in its checkered towel. Another time, wearing fluffy afternoon dresses, three more or less buddies came visiting, girls who thought I was one of them until this. Their violent unsatisfied curiosity floated around the afternoon cabin in a positively miasmal drift, a heady effluvium that mingled with the reek of crushed verdure and lake water. Unabashed questions did not even wait behind their chairs but moved with the foolish conversation on the porch, heavy as gases and as hard to wave away.

Once a boy came, ah, *he* would have made sense for them— came dragging his tennis racquet and his courtly (courting) manners; looked a lot at the empty cots and then back, in clumsy longing, at this weirdo trying to tell him a little something and failing utterly. Because that was not it, and he had to be got rid of, sweetly, no fuss.

After that there were the long solitary days, the ungodly silence into which dipped the rain's whisper, faraway boaters' banter sounding surprisingly near (that voice, was it someone I knew perhaps?), an evening bird lighting on the roof, hopping on it. Cats could be counted on to fight up there, too, and numerous twigs to snap, at night. There was no fear, no boredom; only the leaden concavity where fullness failed to appear. Because failure was the shape of two weeks at Lake Bracken and the thought grew and spawned a crystal answer that froze into a certainty: lakes are made to drown in.

Among my duties at the library was a weekly reading of the stacks, according to the then-prevalent classification, the Dewey decimal system. The trouble was, once I had got back among the shelves, it was hard to find me, and the head librarian, a resolute, imposing woman, wearing pince-nez that trembled on her nose when she walked, would sometimes flush me out herself, in a perfect towering rage. Standard-bearer of morality according to her lights, she had instituted an ingenious method of marking with a small red cross under

the catalogue number any book that she considered immoral, unfit for minors. Thus I had no difficulty in finding the best books.

Erewhon, *Leaves of Grass*, *Tristram Shandy*, *The Scarlet Letter*, *The Red Lily*—dozens and dozens of them, getting all mixed up with the others, on the shelves of that corrupt stony structure flying the American flag and bearing the names of great men incised around its entablature. Over the years, the library became my haven, its treasures slyly challenging the voice of "Art," its sirens singing and crying by turns, filling my eyes and ears with words, its weight crushing my fatuous certitudes forever.

Twenty-five years later the Galesburg Public Library burned to the ground, its 200,000 volumes feeding the sky-high flames while the town's water supply sputtered out and my sisters watched with tear-stained faces. Thank God I wasn't there.

Not that I never went back. Often, at first needing pretexts such as holidays and mother's birthday. Thus I am remembering mother's colors: jade green, American Beauty red, peacock blue, old rose. While she sews them into her lazy-daisy quilt I am on the Chicago train to Galesburg. Last gasp of memory here: we are four, we are going down to the homecoming football game. I have not the faintest interest in football. My pretty friend is *thrilled*; the two boys are happy medical students with medicine bottles of government alcohol, 140 proof, something extravagant like that. We are at the water cooler in the swinging train, where you slip out cone-shaped paper cups and fill them with ice water at a miniature spigot. Fire sears the throat at the jaunty tilting of the little bottle and there is a scratch of laughter to mask the first time. (For God's sake do not cough.) How the train speeds through the stupid landscape! How screamingly funny it all is at the dance! My future medico clings to me as I to him. We are in stitches. When you have four feet you can keep standing up. I have his two besides my own, he has my two. Not only we do not fall, we manage the slides, the turns, the sudden rhythms.

Each held fast to the other, my eyes were mostly closed, not to see the mile-high waves around our upended deck. I was

probably happy the way people have always been happy on the dance floor. The mirror ball sends its chips of light circling the universe, nobody watches you, nobody cares, the musicians are all Olympian benevolence in their smart pink tuxedos, gods smiling down into your half-open mouths, providing gently pagan rhythms that coax you into wanton concupiscence and make you forget that tomorrow is Sunday and church where the stained-glass windows are jade green, American Beauty red, peacock blue and old rose.

Now after many years a sudden desire sends you back, just a short visit, your bag stuffed with handcarved notions wrapped up in a tender woolly image of the separate little person you once were.

Separate you still are. And you think you know everyone, that they know you and that you will somehow amaze them. But the town has grown, though this may not be at first evident in stepping off the train. In fact it appears to have shrunk. There is a lot of hollow wind in the depot, blowing dead train tickets and gum wrappers across the floor, but there are no people except an old man with a broom who stops sweeping to stare at you when you ask about taxis. The coffee shop? He doesn't remember. A car drives up and delivers your sister who hugs you and takes you away from there. Sitting beside her, half listening, you are quite lost. It is the wrong town.

Can this be Main Street, so queerly empty to the eye, so drab and quiet? Itching with ghosts in the crisscross gusts that sweep clean like a broom past empty store windows and that separate the dust on the inside from the dust in the street. A parking lot gapes where once you tried on gloves at a mahogany counter or bought a hat for too much money. What happend to Lescher's soda fountain, and the Alcazar, gentle macho haven where my father, being a male, could buy his Sunday cigar? Where is the big bank window where shaky paper currency from all over the world was displayed with a United States one-dollar bill in the middle and the legend: *Good old American dollar, always remains the same.*

The big trees, lofty Sherwood Forest trees, where are they?

Our proud Galesburg trees. They leaned together in long ogival files that made tents of the streets, gallerias with leaves for glass. Where are the trees? The town is dense and fat, cubic, a smokestain on the land; and now you are not a part of it at all but only a speck among many unknown specks that you see as in a culture, starkly, darting around oblivious of your mixed feelings. It is simpler that way, you tell yourself, another place altogether, bottled and corked and labeled, an elixir gone dry.

"But you wouldn't know."

Max: "I think I do. The place you had to leave. Everybody has one."

As the days became nights and the months years, my soul detached itself with reckless finality from that warm and comforting quotidian. It watched gravely from a distance as the body went about its vain gestural procedures. It waited with patience while the big trunk, sporting brass corners and five latches, got secretly packed. Goodbye, Galesburg. Goodbye, Anatole France. Goodbye, public library.

Now the trunk can be sent for, openly. My letter, "It's in my room" and "Just take it down to the depot," was read aloud like a death knell by two shocked parents. Their grief: a warm luxury that I could not but treasure, because I was alive.

Chicago, clanging, blowing and steaming with glut, wind, lust. Here—this is 1934—I meet my first eccentrics. They float through antic evenings to the sound of jazz and the tinkling of glasses containing icy drinks. The drinks are made of dubious alcohols, this being Prohibition time. There are thousands of icy drinks and I feel more and more certain of an exceptional destiny—so much is waiting for me.

One of these evenings brought me into an awesome lamplit room lined to the ceiling on all four sides with books, and presided over by a pair of gentle owls about five feet two inches high. They were man and wife, he a compiler of modern verse, she a maker of it. Oscar Williams, poet. His *Little Trea-*

sury still seems so appropriately titled, quite one with the earnest bespectacled face, bird-bright behind thick lenses. As for his poetess, Gene Derwood her name, she personified everything I had not known in Galesburg. Intensity streamed from her very crossed eyes; her hairstyle: Joan of Arc bangs; her small piquant features in their paper pallor; her dark brown cape—somehow I always see her as a sepia vision: brown hair, eyes, cape, perhaps the book she held—all formed an icon of unquestionable authenticity even without the almost inaudible voice, epiphenomenon that achieved my total devotion. In a group discussion later, one of those rambunctious arguments that spring up among showoffs, I had only to see her stand up in her magic cape and object—"Fellow, fellow!"—to know that I had found a *milieu*.

How did they come here? How had the books, floor to ceiling, door to window, flown in to these shelves, clinging there close, close together, congregating on this softly glowing shoal in their long flight from where to where?

The whole scene struck me as a kind of *tableau vivant* that was to be gazed at, taken in quickly before the curtain fell. How long had they been here? Not long, surely. The talk always referred to New York, the only place, the end of any voyage. Yes.

They planned daily the thousand-mile trip, with stops for sleep and sandwiches. Carefully. For money was the stumbling block, the element that kept their ailing jalopy in the garage instead of on the highway, eastbound. By and by we planned the trip together, except that their two wistful faces were grave when I admitted that I was as out of pocket as they. Oh, I would pay my part. I would manage that. And so the date was set.

It did not seem remarkable to me that I was packing my trunk again, this time for New York. Had I not, at age seven, decided I would live in Paris? And was not New York on the way? The whole procedure of packing, the choosing and rejecting, the meaningless fidelity to perfectly useless objects, the rash discarding of probably useful ones, sloughed off like

the familiar keys, corridor, room, faucets, India prints I was leaving forever, all was as natural as graduation from some school or other.

Then, two days before departure, I had a phone call. The car was still in the garage, prostrate. It was too old, diagnosed the doctor-mechanic. It would require a heart transplant, a constant oxygen mask, a set of four new shoes. Our adventure was indefinitely postponed.

Have you ever unpacked a trunk—the one you had been filling up for weeks with your earthly possessions—before it has gone anywhere? The very possibility of such an about-face was unreal. Tucked into every object in the trunk was a piece of my continuity and my decision, so that should it all be removed, thrown out, turned back into abandoned drawers and empty closet, I myself would be so turned back, scattered, hopelessly dispersed, like a routed army, with nothing left but surrender. Even unpacking a suitcase after defeat by arrogant airlines is a melancholy business, all too well known to present-day voyagers whose flights are airily canceled at leering last minutes. Picture, then, the would-be New Yorker on her haunches before the trunk that holds her life's accumulation, everything from the portfolio of drawings on the bottom to a box of watercolors, Uncle Bob's cigar case stuffed with rolled-up stockings, snapshot album, leather notebook, insignificant trash of all kinds without which the traveler would be a shadowless, no-dimensional wraith. It is clear to her that a voyage has to be undertaken.

"You are going on a journey," says the fortune-teller. Oh, you are right.

At the bus station on the scheduled day of departure I bought a one-way ticket for New York and after rocking and lurching, asleep and awake, through the September countryside and faceless towns for an inordinate number of hours, I was disgorged with the dreadful trunk at New York's Greyhound station down on Eighth Avenue. "To Greenwich Village," I order the taxi driver. "But where?" "Just go there. I'll tell you when to stop." At the first ROOM FOR RENT sign we pull up. I go in, take a look, pay five dollars to the landlady, who

gives me a key to the room (a minute windowed closet), the driver brings up my trunk *on his back*, and in five minutes the door is closed and I am a New Yorker.

That evening my notebook is out of the trunk. My pencil is poised just as if that taxi had simply brought me from around the corner where I had been waiting.

> *Red sign, yellow cab, blue door*
> *A photo black and white but not*
> *Really: colors are trembling*
> *Around the edges before night*
> *Falls. A daylight night*
> *Blue-green and the taillights*
> *Red.*
> *Red on blue and green.*
> *There are dogs, dog-color*
> *Men with guns, man-color*
> *All the colors of virus, fleshly.*
>
> *I go in because it is there*
> *Purple evening playing a card*
> *Pumpkin-red fortune, mauve shadow*
> *In the rooming house*
> *Red sign purple cab blue boar*
> *Brown dog*
> *Cigarette glows orange. A boar hunt*
> *Cannot be regarded*
> *There is no color in it.*

Anyone could see this was a feeble poem, if you could call it one. But it had a rag of willfulness, the color scheme was aggressive and that gave me pause. It was clear to me that I should be an artist in an artist's studio where such tendencies would be a positive help toward self-realization.

Max: "And then what?"

<div align="center">*</div>

A few lines for a few years. A line a year—is it worth more? Because some years leave no stamp on the mind. They are like mere series of dots marking something foggy, dim, breathless, up in the air. Put a few dots after a word and you have a year's worth of unanswered questions, to say nothing of audacities, plights and errors in abundance.

The fact is, one doesn't care too much about remembering them. The draggy jobs, the squandered evenings, the obsessed boyfriends, the relationships; the return to home base for breath; the sometimes perfidious girls with whom I shared rooms, apartments, confidences. One of these, not perfidious at all except perhaps in the eyes of my parents had they known, once got me out of the family bosom by an urgent letter about a job, a little ploy we had dreamed up together.

Of course the job was ninety-five percent invention, but in New York and in her brownstone apartment on Fifty-eighth Street, everything was possible. We shared rent and curry powder sandwiches, took Hindu dancing, read the *Bhagavad-Gita* and Emily Dickinson, impartially. We wore grass skirts at an appliance convention dinner, serving strange pink and yellow nourishment on beds of banana leaves to bewildered refrigerator salesmen, for which service we collected five dollars upon leaving at one in the morning. My sidekick found this mirthful; I was dispirited.

Her name was Ronnie and she was the happiest person I have ever known. That her art—for she was an "easel painter" —piled up in the spare room instead of hanging in art museums cast only the palest shadow on her unbelievably sunny outlook. Never having lived anywhere else, she still loved New York with a steady passion that sent her, propelled her, hurtled her into every event called public. A city block could be a miracle; a concert, an exhibition, a ballet was always sublime. Later years brought her hippies, rock stars, junkies, punks; she loved them all. "The scene," she called it, not even suspecting that it would lose a bit of its luster without her.

These were our nineteen thirties when most New York art galleries were huddled in the comparatively narrow confines of Fifty-seventh Street between Third and Sixth Avenue.

If you walked along Fifty-seventh Street from Fifth Avenue to Lexington, up one side and down the other, you were rewarded by an exciting though spotty exhibition of European pictures, with a timid sprinkle of American ones hanging in between. What was remarkably happy about such a promenade was that more than half of the great ground-floor spaces on this very handsome street were so occupied. And though many other galleries were tucked away on cozy upstairs floors, it was the big gallery windows that provided the fun when in the evening two embryo artists stepped out to "take the air." This we did quite regularly, in all but the foulest weather, bundled up against the wind that blew from around the corner on Fifth. Every second window was ablaze with French impressionist paintings in curly antiqued frames or German expressionist ones in gold frames. The American pictures sported low-keyed baguettes.

Magical Fifty-seventh Street was, in fact, our academy. It was where everything worth looking at came and went, only to make way for the next masterpiece. Blithely penniless, we could walk into any one of its carpeted, paneled, museumlike interiors, stand before the pictures or sculptures, and discuss them undisturbed. We had strong opinions, but kept our voices down as—have you ever noticed—everyone does in art galleries.

Here and there among the "greats" nestled a few staid shops selling English hunting scenes, or Meissen cabbages in porcelain, which we ridiculed happily. There was a shop of "*curiosités*" (their word), its immense window crammed with those dusty, brown, ill-lit objects that passed for primitive art. One snowy day we, the same two stars of the future art world, lingered there, wanting, as one always does, to spot something "good." Indeed, in we went, and in no time at all had bought a little brown statue. We then changed our course back toward Third Avenue where, under the roaring el, a delighted merchant bought it for a nice markup. Then we changed direction again and headed for a good restaurant. *On fait ce qu'on peut.* Occasionally we would swing around for a few blocks on Fifth Avenue. Here the displays of dresses, so close geographically to the ineffable visions around the corner and yet so far cosmically, unleashed our sneers. We laughed until it hurt. The

giddy inanity of mannequins in their strange garments, their unawareness of their silly selves, like the swaggerer unaware of the donkey-tail pinned on his back, turned our snickers into hoots of scorn that echoed in the late-evening street, and we staggered back to our fourth floor, well pleased with ourselves and the evening.

One such day in 1937 or 1938, after closing time, we edged into one of our favorite galleries (was it Paul Rosenberg?), where there was already a little crowd of nobodies like us sitting on the floor before a large Picasso painting.

We listened as a gaunt, intense young man with an enormous Nietzschean moustache, sitting opposite us, talked about the picture. It was not his accent, which I couldn't place, that held me, but the controlled passion in his voice, at once gentle and ignited, that illumined the painting with a sustained flash of new light. I believe he talked about intentions and fury and tenderness and the suffering of the Spanish people. He would point out a strategic line and follow it into battle as it clashed on the far side of the picture with spiky chaos. He did not, during the entire evening, smile. It was as if he could not.

Only afterward I was told the man's name: Arshile Gorky. A rare moment, as I in my structure-proof life move on, not too dashed about washing out stockings at night so they can be worn again next day, not too vexed about propping my never-larger-than-twenty-inch canvas on a chair for want of an easel, not even maddened by flimsy friendships based on circumstance.

Because in 1936 I look in on the *Fantastic Art, Dada, Surrealism* exhibition at New York's Museum of Modern Art. Of course there have been intimations: the great Armory Show of 1913 —too soon for me; books, albums and catalogues from Paris; magazines, too, and enigmatic pamphlets; surrealist shows at the Julien Levy Gallery (lots of financial flops here, I learned afterward. For instance, not one picture sold from the first two Dali exhibitions).

But here, here in the museum is the real explosion, rocking me on my run-over heels. Here is the infinitely faceted world I

must have been waiting for. Here is the limitless expanse of POSSIBILITY, a perspective having only incidentally to do with painting on surfaces. Here, gathered inside an innocent concrete building are signposts so imperious, so laden, so seductive and, yes, so perverse that, like the insidious revelations of the Galesburg Public Library, they would possess me utterly.

From that day "aberrance" was for me a meaningless three syllables, and "deviate" another three, synonymous with minority. My own drawings, technically timid scraps of old obsessions, stayed underground.

There was a day in July 1939 when I boarded a ship bound for France, last lap of that lifelong itinerary that had begun in Chicago. My pockets were full of letters (not much else) of introduction to artists, Soutine, Tanguy, Max Ernst, —"Oh no!" "Oh but yes." Picasso, too.

But no one is at home. No Parisian is ever at home in August if he can help it. Somnambulist *concierges* (they frown before you open your mouth, anticipating what?) shake their heads, *"Il est à la campagne."* They stare at me, doubtless wondering at this bizarre American who chooses to ring doorbells in August.

An especially doomed August—a city paralyzed by anxiety, breathing painfully before the imminence of war. With a big lump in my throat I wander the wide deserted avenues, the gardens, the museums. I knock on mute doors, I get lost in the labyrinthine streets. I am hungry at the wrong times.

Back in my room, at loose ends, baffled and feeling insubstantial, I sit with my sketchbook, drawing Paris from the window. I draw the clouds that are so patently French, draw the roofs, the vanishing streets, the houses' patinas and their patience, draw them urgently as a spy would use a special camera, would hide behind a curtain just as I am lurking in my hotel room, to snap something fleeting, some guilty evidence, a perhaps sad secret.

Outside there is nothing simple, not one person I know or a friend of a friend. There is only a firm resolve planted like a

tree in my determined *avenir*: to come back. My artists? They too will come back some day, say the French clouds, the deserted cafés, the pearlgray streets.

Soon the war is there like a train on time. My embassy says go home. The telegram from my father says go to Stockholm to Uncle Hugo. In order to do this there is only the (disrupted) train—across Belgium, across Germany, with queer stops and queerer changes of trains, my ridiculous luggage somehow keeping up, not quite missing connections. Burly Hitler youth kept me company; oh, I had quite an entourage in those hot smelly trains where there were no breaks for day and night, needless to say nothing to eat; big bold boys in short khaki pants, their knees, their terrible iron knees . . . their insistent baiting that got through to me in spite of scrambled words.

"You Americans, you think you have an air force. Your pilots, ha! We will take care of them [laughter], the *Reich* will show them, our *Luftwaffe* will bring them down like ducks," and so on and on. I smile and smile. After all I am in Germany and these boastful boys with strong blonde hair on their steely thighs already know (how?) that my country will enter the war.

Paris had withdrawn from me, spurned my embrace, turned her face to the wall. Thirty-two days studded with failure had blasted open my eyes and my mind. Germany was a train ride complete with grotesques. By the time I reached kindly Stockholm I had rubbed elbows with enough collective madness to know it would never matter what I might think of what was happening. So the voyage had not been for nothing. Something had been achieved after all. Never again would the sound of political harangue embarrass my other-tuned ears. Never again would I sit in burning, uncomfortable involvement at meetings in which I did not belong. Never would I confuse heckling with heroics. Dreams were dreamed, but not mine.

Besides, had I not already begun on something else, something lifelong with a stop at that Dada-Surrealism show three

years before? So by the time surrealism would come to New York in the guise of exotic human beings, some time later, I would be ready for it, ready with my pictures, ready with my thirty birthdays, ready for this story to begin, to go on, to begin again.

At Uncle Hugo's place outside Stockholm a yellow-haired girl in starched blue and white, with sumptuously upholstered bones, with perfect bare feet and with whom I cannot exchange one word brings my breakfast tray at nine: the usual things with, in addition, a generous plate of herring. At eleven another breakfast in the dining room, attended by Uncle Hugo who tells us Poland is now divided like a pie, Soviets and Nazis at a tea party. Oh, when I get back! I can hardly wait. What will they say now, Jerry and Greg and Joan and the others I knew there? Of course they had something to say. But it was lame, lame. I thought hard.

To calm my turmoil I painted Aunt Hannah in oils. She took this as seriously as if I were a commissioned artist and insisted on dressing in silk and wearing her pearls. These demanded my most strenuous effort—think of it—one pearl after another, and another, all evenly matched, *of course.*

Dry leaves were falling, skidding across the frosty grass. Winter was racing toward Stockholm; Nazi mines were planted in the North Sea.

"Stay, stay," begged my gentle cousins. But all I wanted now was to get home, if the war would let me. From Gothenburg, on the *Gripsholm*, it took ten days.

It did not take long for daily deeds to take over, however, once I was safely on the dock in New York. After a while, and in spite of agonizing news from those places I had so recently known, it was as if I had not been in Paris at all.

When not bent over the drawing board (ads for Macy's: girls, girls, girls, in bathing suits, girls in dresses, then girls in fur hats or Ophelias drowning in a new cologne; a page of fake jewels, a page of handbags . . . handbags!), I sometimes scavenged for bargains in places like Klein's, a cut-rate clothing store on New York's Union Square, treasured at the time by

indigent girls and women, treasured for its heaven-provided
bargains for the young and urban hopeful. A five-dollar dress
in which to stand before the future, a black dress, "a little
black dress" is what they were saying that year, and it was like
winning the lottery because it was found. Tried on in a large
balefully bright room, the eerie green paint made liquid by a
looking-glass wall. In this tank of waving, contorting, neon-lit
swimmers, the mirrors coarsely reflected bodies of the not
quite poverty-stricken. Here a tumult of women dropped their
skirts and slips on the floor, clutched their handbags between
their knees or between their teeth. They discovered their sad
flesh to each other who did not care, while grabbing the object
of their choice—choice, that kernel of glory in the pit of
despair—to try on, if possible without lipstick smear, ready to
overlook the limp collar, missing belt, broken zipper, opened
seams, ripped lining, all signs of use by frail and ineffable
models who were not there that day, only us others, who
pulled and twisted the hapless garments over our heads or feet
first, and for some, up to the bulging girdle where, most often,
they wouldn't go any farther without their adversaries' relent-
less determination to be in them. If there was no one looking, a
quick tug defied the recalcitrant opening, and a small dry pro-
test of tearing rayon imitated pain.

Contortions justified by our perfect choice, looking neither
right nor left, oblivious, intent, we shared the wavy mirrors in
our frenzy of frivolous hope. At nightfall these five-dollar rags
will be transformed into raiment. And seen from across the
people and the shaded lights, barely outlined in the chiaro-
scuro hour, the dark envelope will be chosen for the second
time in one day, this time for the life inside it. Hours later,
having served its purpose, it will be dropped on the floor like a
shed skin as a new time span begins.

"And that's when I came in," muses Max.
 "Yes," I answer. "That's where you came in."

And even though it may be the middle of the night we lean,
Max and I, over our reverse mirror, peering with a kind of

careful wonder at our first days, first events, first people, our brash leaps, miraculous escapes. We examine the long chain and all its details like the wonderful spine of some perfectly meshed skeleton, an extinct species never to be seen again. Our momentous meeting, the highs, the lows, the exigencies of city life that sent us, headlong optimists, on a long train ride to seek another way.

v *On Capricorn Hill*

Between Sedona, Arizona, and New York City lies most of the U.S.A. Two thousand five hundred miles were spun out and counted by our Fords, eight times in twelve years. Each time a two-wheeled mail ordered trailer carried a load of pictures under its tarp. Each time, because the beautiful, hapless pictures often went both ways, going and coming. Gaily loaded under the desert sun. Stoically loaded to come back minus one or two. An abiding image of that time, stamped upon the red rock pellicule of my memory, is of Max, hammer in hand, crating pictures. It is a fragile thing, the painted canvas. How securely it has to be fitted and fastened, nothing touching its skin, a helpless baby born of mind and gesture.

Unlike the pictures, we could go out at will. A fast dive into the pounding heat to chase away a cow, fill the bird bath, pick the two brave zinnias that had bloomed overnight.

Nature was not always open-armed. An electrical storm could hang a ball of white fire in the doorway. But it was only for a moment and did no harm. There might be a week of red wind that tore at our wooden house. Kept us inside. Multiple veils of ruddy dust rose high, so high in the air that we could stare without blinking at the perfectly one-dimensional white plate that passed for the sun.

In that camera-sharp place where the only electricity was in such thunderous lightning, there were no sounds in the afternoon save the hum of the heat. It was so intense, so lurking, so aged, that we the intruders felt also quiet, intense and strangely tiptoe, as if in peril. It bounced like coiled springs off the burning red rocks and melted the tar on our paper roof. It came inside to sit on my eyes. Breathing was important, an event.

Day after day, surrounded as by an enemy who dares not deal the final blow, we doggedly painted our pictures, each of

us in our own shimmering four walls, as if we were warriors wielding arms, to survive and to triumph. Big gestures such as covering a canvas with quick paint were reserved for evenings. These began early. Four-thirty or five o'clock saw the sun dip behind our hill and in half an hour the temperature dropped twenty degrees, a theatrical quick-change. Crystalline air drawn into burned lungs produced somersaults of energy. One pounded, wrestled, scraped, dragged, swabbed—making art is not a silent affair—until night dropped too, like a clapped lid, and it was time to watch the stars.

Lumber, hatchets, nails, wrenches. The plumb line. They were as essential out there as colors and canvas. In league with saws they built our wooden house just as they built the pictures' crates. So that we, fragile creatures like those pictures, could be enclosed, roofed, locked inside, nothing touching, unbruised and intact.

Reader! Imagine the pure excitement of living in such a place of ambivalent elements. Overhead a blue so triumphant it penetrated the darkest spaces of your brain. Underneath a ground ancient and cruel with stones, only stones, and cactus spines playing possum. The evilest creatures of nature crawled, crept, scurried, slithered and observed you with hatred, but saved their venom while you kept your distance, when warned. It was then that you gave yourself up to that incredibly seductive wafture that, try as you might, you could never name. Its components? The red dust, the junipers, infinitesimal desert blooms, the stones. Even the stars shed perfume with their light when, sitting outside, we watched them slide rather slowly across the sky.

There was always something attractive in perspective. A visit from Marcel Duchamp promising a veritable chess fest; Man Ray, his car stalled in the mud for three days; Balanchine and wife Tanny Leclercq on their way to Stravinsky's in Hollywood; even Dylan Thomas who stayed a week and regaled us with violent declamation and bibulous monologues.

An event for October 1946. Man Ray thought it was funny. With the intention to marry, we had come to Hollywood,

where he lived. Getting married in Hollywood! We all laughed about it but the next morning he said, "Maybe we'll go too. If Max can do it so can I." And added, ruefully, "Though I've never done anything so *rectangular*."

On October 24, 1946, therefore, a double wedding in Beverly Hills united, *in the eyes of the law*, Max and Dorothea, and Man and Julie. There. It's said and done. Painless, forgettable.

Once again in Sedona, we deal with the stubborn desert. In the cool mornings Max tends his garden, digging little trenches and dams to make a firm intention for water. Only, the rain never fell. Until the big well was dug, canals and trenches gaped like toy-sized arroyos remembering water they had never known.

Inside the flimsy house our friends of the wilderness: masks, totems, spears, potlatch, the ones we had brought from New York. "Where did it come from, Max?" I would ask. Answer: "They made it for you." And I, insisting: "But who did, what does it mean?" Then he, losing interest, "Oh, it's Tlingit" (or maybe he said Kwakiutl). He was already elsewhere. And when photographer Cartier-Bresson came from Paris to Sedona he considered the wolf mask, its hairy ears and wide copper eyes. "Elie would never sleep in the same room with that," he remarked of his wife. As he spoke the mask visibly flashed its terrible abalone teeth. From that time on, if I didn't actually fear it I was respectful.

There in the red world of jagged souvenirs signed by the great glacier, pioneers named their scenic views to bring them down to size. Cathedral Rock was a ruddy mass imitating for those childlike settlers a cathedral. Courthouse Rock, noble giant reduced in name to a reminder of fiefs and files. Just west of Sedona was Cleopatra's Nipple. It isn't known of course who named it so, nor why anyone as remote as Cleopatra should occupy the imagination of an American cowboy—for it must have been a cowboy—but it was often thus pointed out to us, just as naturally as the other poverty-stricken titles. Coming back years later and encountering an entirely different population: retirees hoping to live ten minutes longer than they would elsewhere, failed doctors with cloudy pasts, wist-

ful but determined unpublished writers, painters with camera eyes and a penchant for scenery, old adepts at new religions or, in general, people who didn't get along with their relatives back home; coming back then, we found that Cleopatra's Nipple no longer existed; its name had been cleaned up by less fevered imaginations, that it was now known as Chimney Rock and had never, in anyone's memory, been called anything else.

Then as now the decibels of nature can crush an artist's brain. I have seen it happen. So I lock the door and paint interiors. Great events. A white and dark picture would muffle the red world outside. Big bare rooms with white frozen figures, like Sodom and Gomorrah. There is opalescent light and velvet dark. Isn't that the artist's best joy, to control light? To rival the sun and moon, to turn their logic upside down with brushes and paint and monstrous ego? I am here. Arthur Rimbaud, mad poet, is here too, on the blackboard in my canvas. What you see there are notes from his secret notebook. Private, impudent signs. The door is not a door on the wild red garden, just on a little something personal, like the door of a house looking in. Students invite a frosty beggar; they all peer inside and make me think for some reason of the way certain birds tuck living ants in among their feathers. Only, we are on the inside and the birds are outside swinging in the scrub firs and equated with stones and scorpions. In here, out there. It is all something seeable but removed, and brings to mind, you might say, a rare iridescent bug which is also a victory of a kind. *Interior with Sudden Joy*, the title.

"This is Capricorn Hill," I said one day. Max looked for a while at the stony, cactus-armed rise, the cleared track where wheels could turn. "Yes."

It was a great day when water was brought from under the hill. After a year of hauling we had only to turn a spigot. So that next day Max could begin a monument to our Capricorn Hill, a king and queen in cement and scrap iron, regal guardians for our house, our two heroic trees, our paints and brushes, our precarious peace. What else could he call it but *Capricorn?*

*

More than just an extra feature of a house is its name, the name it wears with pride behind its lighted windows. Solidly planted in the books I had dreamed over since school days were those houses with names that not only proved their existence but chastised the geography surrounding them; so that river, village, hills, lakes and even mountains were hardly more than shifting background in the mental picture of the house with its magical name.

In Arizona there was nothing about our made-it-myself-two-room house that visibly merited a name. Capricorn Hill. Alone it stood, if not crooked at any rate somewhat rakish, stuck on a landscape of such stunning red and gold grandeur that its life could be only a matter of brevity, a beetle of brown boards and tarpaper roof waiting for metamorphosis. Up on its hill, bifurcating the winds and rather friendly with the stars that swayed over our outdoor table, like chandeliers. On those evenings when there were visitors we might have been Magnasco pirates reveling on a sea-sprayed deck, sails furled, candle lamps steady, while the world spun backward and our voices hung upside-down in the desert night air. Tales were tall, arguments were musical, philosophy gave pause.

Max Tells of Mozart and Others

To him the last real European
Amalgam of all sweet sound
Green gazes came and made of amalgam a potpourri
Green glances came heralding
The tender giant chauvinist thundering fatherland
Panic for chords celestial choir
Based on a bag of hope.
And then that hope broke down in him
While students came to throw their tearful caps
Into the air
They came in brandenburgs out of the brick wall
Tossing caps.

Thus came the weather change.
Thus came Wagner after
To creep to the cross with Parsifal

All this churns an inner maelstrom
Brought to the simmer by sound finespun
There is some element in it
Some consequent hallucination
Still green, a kind of intimate solstice.

You would think that here ends the story. You would think
that those velvet nights, preludes to each passionate day in a
landscape so charged that "if Wagner had seen this his music
would be much louder than it is already," we said; you would
think, then, that paradise would hold us in thrall, sustain us
hilariously in our ongoing combat with need, the creature
kind; would provide the sweep of background—a long lumi-
nous brushstroke upon which to pin, plaster, paste and paint
our questions and our answers for the rest of our lives. Stud-
ded with discoveries in nearby Indian caves, canyons, pueb-
los, aged and wise. Cowboy Elmer, exuberantly in league with
the primordial, guides us through the Colorado River rapids
(replaced now by concrete dams) in rubber boats. He pitches
tents, makes cowboy biscuits and shows us Indian hieroglyphs
in fastnesses where the invader (we) had never walked.

Precious as silicate arrowheads, of which we found several,
or diamonds (none) is the memory of that nine-day river pas-
sage, eighteen miles on the torrent that cut skyscraper deep
between sheer stone. The shiny autumn silence that listened
to water, black shadow that swallowed light and hid our bob-
bing rubber boat in a seeming underworld ready to be drawn
by Gustave Doré, a paradise lost, no artist's tricks needed, not
even imagination, it was all right there before our eyes along
with a phantom presence of Indians, eyeing us from up there
on their rim or lurking in cave and cranny. Uneasily. Because
it was theirs, and even at this late date we were intruding.
Guide Elmer moved respectfully through the gloam. For
hours on end no one spoke. Arriving at Lee's Ferry two days
late—we had played at movie-making in a hidden canyon—
we were hailed with relief by the locals, even newsmen, and
our movie footage was nicely integrated back in New York in
Hans Richter's avant-garde film, *8 by 8*.

It all showed, alas, that paradise was indeed a somewhere

not quite habitable, or even believable, or—can it be?—desirable. Were Adam and Eve really chased from the garden? Or did they leave?

Hung about with valid reasons, if such were required, we locked our flimsy door and left for France.

VI *Under the Mansarde*

August 1949. Antwerp, where we dock, is in full carnival delirium. An Ensor carnival (How conditioned we are by pictures!—a Turner sunset, a Vermeer light, pale Friedrich mountains, a line of Daubigny trees, a Schwitters billboard, a green apple for Magritte, a *percheron* by Rosa Bonheur, the list is endless, nature is seriously compromised . . .), the perfect recreation of his grotesqueries, the brass noise, the brassier colors, the hideous grinning masks that are loathsome caricatures of their wearers, dead or alive.

Death is dancing in the streets, death is a bear, death is a dwarf running on tiny feet, a paper hat to be trampled by fat sunburnt legs. Around the corner suddenly. Quiet, airless-seeming, a narrow street of ground-floor bay windows offers a regular consortium of death. In each one, framed in ocher varnish, lace and potted plants, a leering orange-haired, yellow-haired, black-haired woman placidly knits or crochets. Or fans herself. She is of course one of the masks, like her neighbor; they are eerily interchangeable, one after the other, all the same, the same, defying any anarchy of distinction, bringing on, finally, that maddening uncertainty of place felt by the wanderer in a hall of mirrors.

And finally France. It was altogether a space of twenty-eight years and could never be confused with time-lapse. Filled it was with astonishing myths in the making that came to stay. People were unique and poetic. In this giant space there was always room for more eucalyptus-lined roads. Imprudent eating shared hours with monuments living and dead. Shall I ever forget the rose that Picasso broke from his dooryard bush for me? Of course he knew I would not.

But, to begin.

*

The Paris winter of that first year is stringent. Poets and peas-
ants alike, hunched in stiff, hard overcoats, haunt the café,
hoping to hear of a room, half a room, somewhere, anywhere
except the hotel. The hotel too is hunched and stiff with cold.
We are lent an apartment with studio on the quai Saint-
Michel. It has damask *tentures* and handsome rugs. From its
lofty balcony we look down at the superb sweep of the Seine,
flowing between us and the Cathedral of Notre Dame.

This stylish pad that we were privileged to inhabit for two
months, January and February, was dependent for heat on two
delicate porcelain stoves, pretty little things called *mirus*,
which had a distressing way of simply going out instead of
burning the coal we heaped into them. Outdoors, on the side
of our number thirteen, a tall column of yellow ice (from the
top-floor toilet) clung like a painted waterfall. As pipes burst
so did our bubble. Braving the icy studio, Max's hand did not
thaw enough to grasp a brush.

In the salon we sit tight on the satin chairs, bundled in
sweaters, coats, boots, a cold marble chessboard between us.
Mirrors sparkle like ice cubes while in the kitchen drops of
grease congeal white on the pans. We make tea, gallons of hot
tea and Max scratches a hole in the frost on the windowpane.
Yes, the Seine is frozen over.

"*Allons! Les misérables.*" There she is, our *concierge*, our life line
who, a week later, wangles us our own space: two tiny rooms
under the *mansarde*, with comfy stove and lumpy bed. Our
first Paris home. Attained, they would say, by means of five
flights of stairs. Not minded at all, especially going down, for
it meant that we would sit in the warm café glassed in for win-
ter, with stove, stovepipe, chessboards (you brought your own
pieces) and gray, milky coffee.

Soon Marcel Z., a chess-playing friend, will arrive. Hand-
shakes all around. We play and he defeats me with ease and
much gloating. The hot smell of damp overcoats huddled in
the corner like sheep out of the rain. The lovely, steamy si-
lence broken only by hard-thinking sighs or my opponent
drumming (unfairly, I think) with his fingers on the formica
table. The short winter afternoon gives up trying; lights go on

in the boulevard and go out in the boutiques across the street where tradesmen, coming out, bring down their iron curtains with a grinching crash, lock them at the bottom, and walk away.

Time for dinner, more handshakes, *au revoir* and the Restaurant Charpentier around the corner, a place of high understanding and low prices. Our own Man Ray is there. American in *béret basque*, our wedding twin, hovered by his Julie, soft-spoken sprite, light of his life. "They smashed the window," he sadly tells us. A little gallery had been showing his objects. The by-now famous metronome, the housewife's iron sprouting tacks, the *Pain peint*, a loaf of French bread painted blue. And in the Paris night hooligans had destroyed them. DEGEN-ERATE, they had scrawled. "My things utterly ruined," said Man. He always said "my things": objects, photographs, paintings.

Scion of this restaurant dynasty and whirlwind waiter was Ern*est*, who knew everything, it would seem, about the U.S.A. —mountains, populations, rivers, presidents, the sort of infor mation found in almanacs and reburied in them at once. *"Tiens, connaissez-vous les capitales?"* And he would duck his head to my ear as he set down the steaming ragout, to reel off the names of the capitals of our states, thus embarrassing us all who knew not. He would go there one day, he said. Perhaps he is here now.

On the boulevard Saint Germain those soft evenings rarely failed to bring their surprises. There, lit by the glow of café terraces and cruising cars would loom the face of some friend, Wifredo Lam, Roland Penrose, in town for a day, Sam Francis or Man Ray. Thus would begin for us all an unexpected evening, over *couscous* or *pot-au-feu*, it didn't matter; with or without tablecloths, but always supplied with wine and the antic story.

It can be said with truth that I learned my French from Madame Guyot, our *concierge*. With her dovelike voice, her immense gentleness, her superb *blanquette*, her expert way of finding the flea in the bed, she quite literally kept us alive.

In fact, she is to me only one in a vast sisterhood of heroic human beings: the French *concierges*. I have never understood

why these patient, defeated women, glued to their miserable *loges* day and night, at the beck and call of a great houseful of tenants, fallen upon and vilified at every *contretemps*, torn from their sleep by late arrivals and early departures—are doomed by fate to remain in their *merde* forever; maligned and ridiculed by worldly travelers and pompous asses who never seem to speak of them as anything but disheveled witches to be borne with. They are, willy-nilly, figures in a Punch and Judy, *bizarre*.

For a while I went daily to paint in a studio on the rue Saint-André-des-Arts, really a small apartment. I can close my eyes and see her before me, my studio *concierge*. *Oui*, *vous*, Madame Turpin, with your great phlebitic legs, your glistening white arms that end in little hands like butterflies, are you still there in the jaws of your recliner, behind the window that looks out on nothing save damp cobblestones and courtyard windows? Does your husband still come home from the weekly cross-country grind of his truck-driving haul to make your bed and tell you that you are still his beauty and his light? Reader, let us thank heaven for the TV.

Madame Deleuze has a white odorous dog. Madame Bertin has three cats. Madame Guyot has one too, a real monster that loves her. That is, there is no other way to explain his behavior when Monsieur Guyot comes home (he too is a truck driver) and Kiki jumps up on the table and urinates in his soup. "*Il fallait le faire couper*," ("We had to neuter him") sighs gentle Madame Guyot.

Every morning she padded into our aerie to light the fire and grind the coffee while we struggled out of heavy sleep, reluctant to affront the shivering day. At last April, a rudimentary spring. We went to the movies. And there found the famous Paris fleas, *les puces*. "They live mostly in the Champs-Elysées cinemas," said friend Marcel. Madame G. was inclined to agree. Sure enough, it was usually after an evening at the movies that I would thrash the night away in an uneven battle with the wretched beasts. Not Max, who remained superbly asleep and unbitten. Fleas. That summer we knew slightly a writer of novels, the Parisian kind: Menilmontant at night, plenty of *argot*, Paris' brawny, untranslatable slang, and girls who wait.

He was the sort of macho fellow seen in French films of yore: tight suit, bedroom eyes, white teeth in view, who had written a heroic and hilarious chapter on these insects. At a *vernissage* I shook hands with him. "Why did he scratch the inside of my hand?" I asked Max. And he, laughing, "Maybe because he is so used to scratching his fleas." So saying he takes me to the other side of the room.

When you are young you are out. When you live in an attic you are out. That is what it means, coming out. They might have said going out. For it is an outgoing process, innocent, the need to know the others. In our case, the need to escape the two slanting little rooms with their stove-burning *boulettes* to warm us, the gas plate where savory ethnic dishes got put together by friends, the cold-water basin that kept us clean.

Behind the wealth of crackled dormers and crumbling walls any corner of which could deliver to the eager eye copious samples of Leonardo's visions, except that for horses, battles, processions, landscapes, we of the glorious present might distinguish drifting up through the flaky surface like photographs wavering in a watery developer, monsters of outer space, rockets, bombs, devastated cities. Behind their frail facades, then, are the poor poets, always the first victims of upheaval, *éboulement*. Living out their uncertain lives in houses that lean, on leaky top floors, *les mansardes*, with water faucets on dim brown hall landings, in rooms formerly occupied by servants and reached by flight after flight of tilting spiral stairs, complete with clammy handrail, broken-hearted hollows in the steps, bare bulbs over the doors. Poor poet, poor Tzara. He refutes his poverty with that monocle. Like all of them behind their abject walls, he dreams big, and all externals fall away before his thundering poem. He had fathered dada in Zurich. Now Paris hides him, a card-carrying embarrassment three flights up a murky staircase.
 Or so I think.

We pressed the bell, heard the tinkle. The door opened and a maid in frilly black and white made way for us to pass into the salon. A blaze of eighteenth-century rooms of inordinate

height (ah, those stairs) where winter sunshine played with the chandeliers and caused lavender-yellow-rose beams to tremble on the worn seraglio carpet. Long windows gave way to a sepia garden conversed with the bare tops of ancient trees.

In a library of leaves: pamphlets, tracts piled high, magazines, catalogues, manuscripts, boxes on boxes, gray-labeled, albums, papers, books—not ancient ones, he cared not— standing among his treasures as if in a paper nest, there was Tzara, amazing Tzara, just as I had wanted him to be. His knitted *gilet* bore a hero's darns and spots. From his thatch of pepper-and-salt hair to the baggy tweed pants there was nothing, I felt, that could ever be changed. He wore, not a monocle, but shell-rimmed glasses.

African carvings hung high on the walls along with Papuan spears, Polynesian masks; a collection living in harmony with pale Louis Seize chairs and an ormolu desk.

"*Le déjeuner est servi.*"

We sat just us three at a round table graced with fanciful Bohemian glassware and placed, curiously, in the big entry hall. We ate sardines and drank wine served by the pretty *soubrette*, and after our spartan lunch we looked at mementos, drawings, letters, poems on ruled paper and a number of those sketchy sketches on paper table-covers. There was a well-known formula for the assiduous scavenger-collector: after the jolly bistro dinner, toward the end of the talk, the wine, the laughing, the antics, at some point there appeared from nowhere a pen, a pencil or even colored crayons. "*Allons, Pablo, comment était ce drôle de flic, comment il t'a montré du doigt.*" ("Come on Pablo, draw that dumb cop, the way he pointed at you.") Everyone drew and wrote and signed. "*C'est ton tour, Alberto, hah, regarde, Portrait d'un cloche.*" ("Your turn, Alberto, hah, Look! Portrait of a Bum.") When the bill was paid (a great bluster here) and chairs pushed back and leaves taken, someone during the merry bustle would turn quickly and tear the "tablecloth," the drawings, signatures and doodles landing safely in his pocket, why not, instead of in the restaurant garbage or restaurant pockets. Tzara's beloved collection, what will become of it?

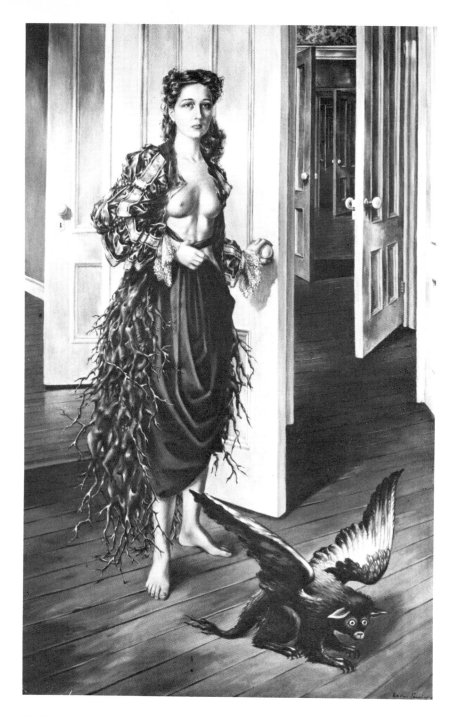

Birthday, 1942. A self-portrait.

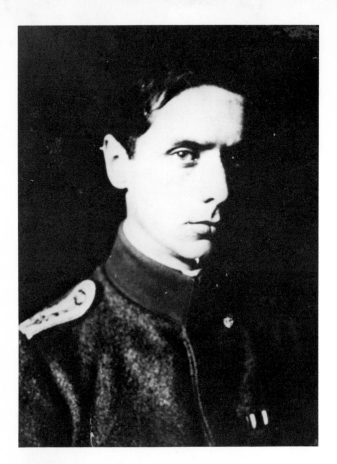

Max Ernst, collegian.
Bonn, 1912.

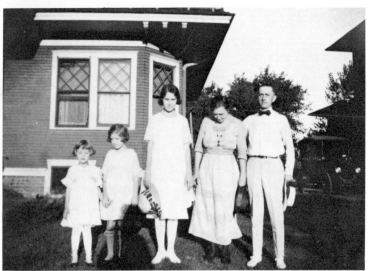

The Tanning family, Galesburg, Illinois, 1921.
(The author is second from the left.)

Max Ernst, 1915, soldier,
wounded and wandering.

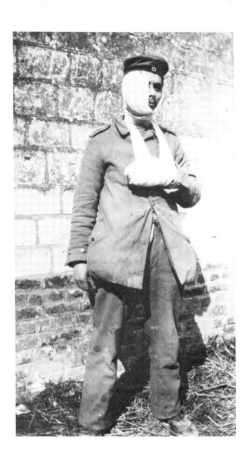

1920. It was the era of the baby star. A feverish friend of
my mother decided that I would be one and, to that end,
took me to a local photographer where I mugged obedi-
ently. It did not stop there and for years I was drilled in
elocution, dying a thousand deaths every time I mounted
a platform. Deliverance finally came in the guise of my
"awkward age."

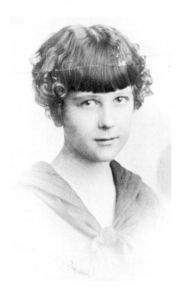

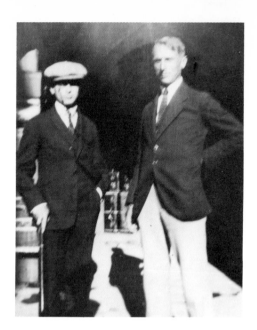

Above: The author at 14.
Right: Max Ernst with
Tristan Tzara (Tyrol).
Below: The Galesburg Public
Library, scene of my
corruption.

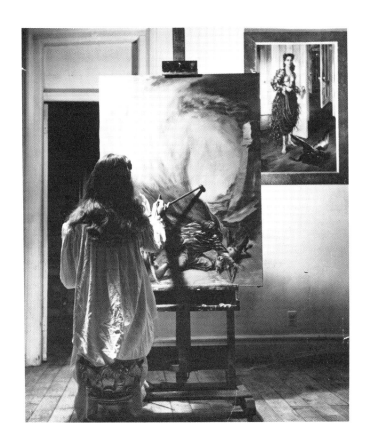

In 1945, a competition was launched by MGM Studios for a painting of the temptation of Saint Anthony to be used in a motion picture. Twelve artists entered. They needed the money. One of the contestants, I have been propped up for the publicity photograph. (I had been in bed with encephalitis.) The contest was won by Max. Another contest, at the Julian Levy Gallery, 1944 (*photo below*) pitted seven intrepid chessplayers: Alfred Barr, Frederick Kiesler, Max Ernst, Julian Levy, Vittorio Rieti and me, against blindfolded chessmaster Koltanowski, all boards monitored by Marcel Duchamp. For the record, everyone lost except Kiesler, who achieved a draw.

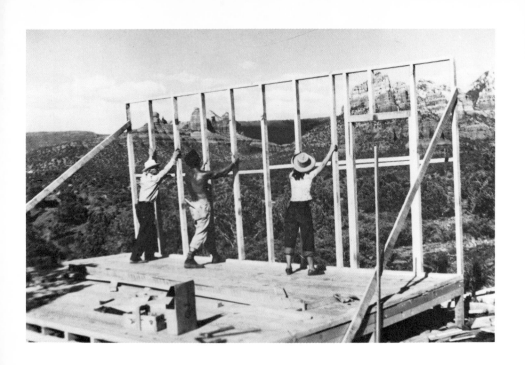

Above: Our Sedona, Arizona house during some of its growing
pains. It never quite grew up. As if it were under a spell rather
than under the sun, something willed its windows crooked,
willed its stone steps to lead nowhere, willed it majestically un-
finished. Surrounding it, and us: the red cliffs of Oak Creek
Canyon. There we had brought from New York the Northwest
Coast totem pole (*upper right photo*) which, incidentally, went
with us to all subsequent rooftrees. It is now in the Musée de
l'Homme, Paris, along with many other tribal pieces as indis-
pensable as bed and bowl. A surprising number of friends some-
how found their way to our savage eyrie. From Henri Cartier-
Bresson came this splendid shot (*lower right*).

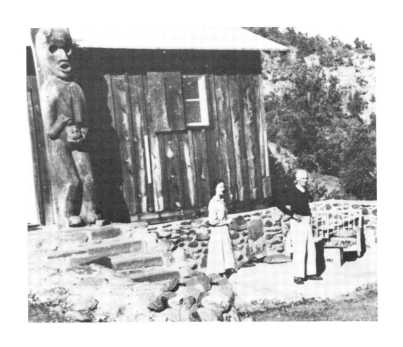

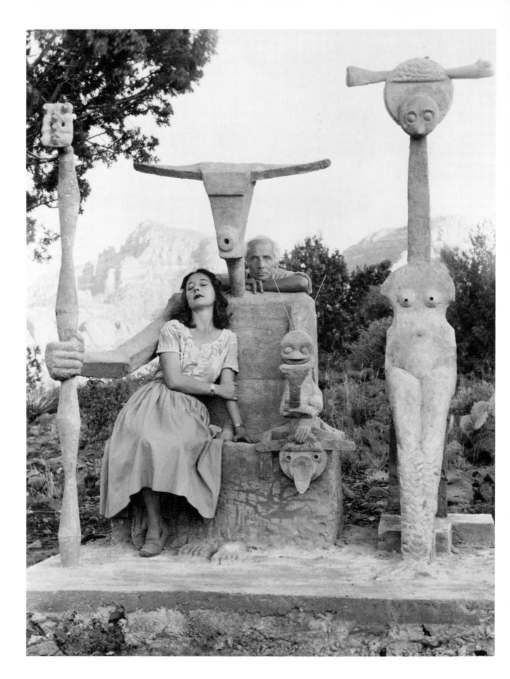

In the summer of 1947, Max Ernst, exuberant and inspired by the arrival of water piped to our house (up to then we had hauled it daily from a well 5 miles away), began playing with cement and scrap iron with assists from box tops, eggshells, car springs, milk cartons and other detritus. The result: *Capricorn*, a monumental sculpture of regal but benign deities that consecrated our "garden" and watched over its inhabitants. Years later, when we had gone, a sculptor friend made molds and sent them to their creator in Huismes, France where he reassembled his *Capricorn* for casting in bronze. The above photo is a one-shot, spur-of-the-moment caper made after taking a people-less documentary photo. (Photograph: John Kasnetsis.)

Right: A goodbye view of Sedona's Wilson Mountain, seen from a would-be window. *Below*: One of a series of chilly, secretive paintings, *Interior with Sudden Joy*, 1951, signed "Dorothea Tanning," that typifies my response to the brash, crushing, diabolically red landscape outside the studio.

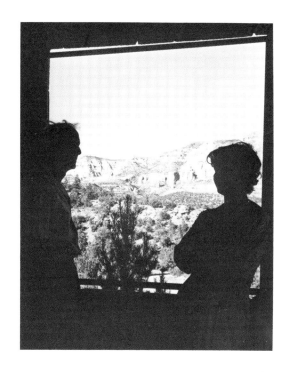

Above: *La Horde*, 1927. One of a series of apocalyptic canvases
that Max Ernst painted with terrifying premonitional urgency.

Above, right: A 1950 snapshot of Paris roofs seen from a perch on
our 13 quai Saint-Michel attic studio.

Below, right: André Breton, Elisa Breton, Max Ernst, and the
author, 1958, in St. Cirque la Popie, a verdant region in the Lot
department of central France.

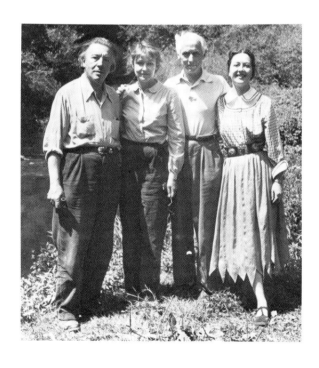

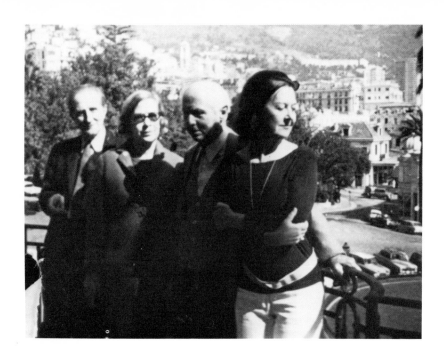

Above: In Monte Carlo with Teeny and Marcel Duchamp for the chess tournament. Equal time was spent watching the greats and playing our own boards. Back in Paris (*below*) I impersonate my dog.

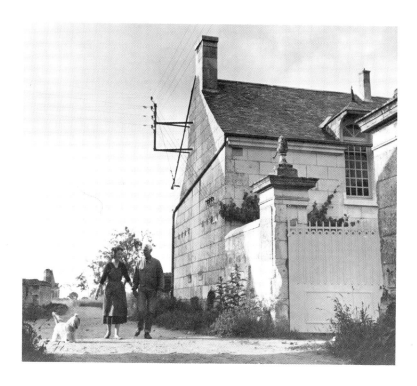

Above: Max, I, and the dog, Katchina, in about 1958 stroll beside our house in Touraine (Huismes, Indre-et-Loire, France), an area generally known as "The Chateau Country," or by an even handsomer sobriquet, "The Garden of France." *Below*: Paris, 1953. Lee Miller Penrose, Bill Copley, Max Ernst, the author, and Man Ray.

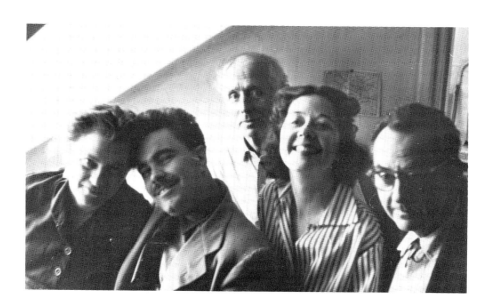

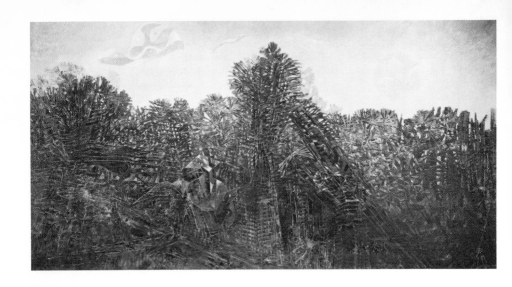

Above: *A Moment of Calm*, 1939–1963, by Max Ernst. Collection: the National Gallery of Art, Washington, D.C.

Above, right: Seillans, in the south of France. The spring of 1967 was dripping with promise; so I undertook the designing and building of a house. While Max Ernst looked on indulgently and, I soon realized, sympathetically, I fought for my dream, a three-year battle for a dubious goal. In June, 1970, we moved in.

Below, right: *De Quel Amour*. Cloth sculpture, 1970, by the author. Collection of the Centre Georges Pompidou in Paris. On one of those fragile Paris evenings where everything weighs anchor and levitates, I thought: What is *la haute couture*? and, back in Seillans, set out to redefine it. Five years later I had a sculptural *oeuvre* made of tweeds, flannels, felt, furry fabrics, all stuffed with carded wool, all made on the sewing machine.

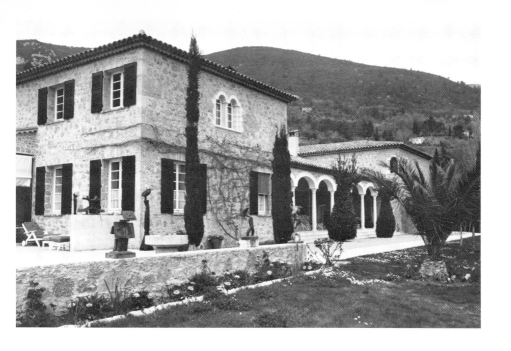

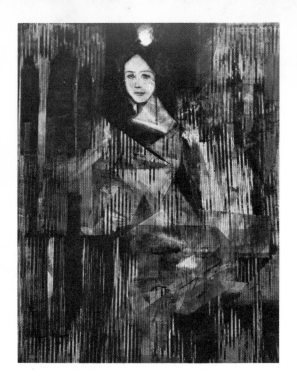

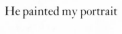
He painted my portrait

and I his. . . .

Full of ferocious wit he could also be cruel. To a fellow poet passing the café where he sat: "Ah, *mon cher ami*, I found a rare book of yours, *rarissisme—all* the pages were cut." (Publishers always left it to the reader to cut the book's pages.)

Now his dada charm had turned to communist clout, and in *Fuite*, one of his plays, I heard the actor say: "Better my chosen chains than a found liberty." Max was not *d'accord*.

It doesn't take very long then to realize that left-bank Paris, where everything, for us, seemed to happen, wears her rags and tags on the outside. A perpetual carnival where disguise and discretion are one and the same. As the caliph of Baghdad donned pauper's tatters to ride among his people, so the Paris street wears its uniform of humble grays that add up to pearl and amethyst, precious as a patina.

So that was it. They all lived behind scarred walls and leaning stairs. Imitation wood-grain varnish everywhere, sticky smelling, better than none at all. Terrifying little elevators into which you squeezed your fatalism and your elbows with the others, saucy Madames de, Monsieur le Préfet, the radical countess, the silent museum director. *"Pardon, madame." "Ooh là-là." "Five!"* "Are we not too many?" Someone leans to squint at the notice. "Three hundred kilos capacity," he reads on the brass plate. General laughter among the ladies, who are of course so svelte. Safely delivered, we are let into the rooms which, as they appeared to my American eye, so often resembled Versailles.

A peculiarly Parisian tendency among a few of its inhabitants was nostalgia for the perfect princely past. That it had been far from perfect does not deter these dreamers from their airless play-acting. But no matter. They are harmless in the main, no more dangerous than children building sand castles on the beach, bless their little hearts.

One is perplexed, however, to see an occasional artist join in the game. What is he up to? Or rather, what is he? His faery world of power melts European history into a sticky mass of titles and brocade dressing gowns. He is in deadly earnest about the gilded past in which he places a few of his ancestors and about his preeminence in the present, all of which works ad-

mirably, providing he doesn't go outdoors. And he has learned how to turn himself off if he does.

I have seen not a few of such people at art openings or luncheons. They see nothing. Or if they do, it is with disdain. Once a painter whose avowed turf was little girls spat like a cat at the mention of Nabokov's *Lolita*, new on the Paris literary scene. "I *hated* that book. I hated it. He has no *right*. Only a highborn artist should be allowed to handle that subject."

Our fief was of course Saint-Germain-des-Prés, with sallies to Montparnasse where another nostalgia is the prevailing malady. It is utterly impossible to walk along the boulevard Montparnasse on a brightly brave autumn day without seeing on its café terraces the petulant ghosts of former denizens haloed by that determined glamour that only intervening time can confer. *Montparnos* of old, French flavored with American, hang around the wicker chairs, sociable spooks full of droll stories but spooks all the same. Even in spring the place looks autumnal with its pale new leaves and paler sun, and some fragile survivor eager to talk about Hemingway or Henry Miller, or Man Ray's Kiki.

One sat at a table for hours, a forgotten glass of something paying the way. Tattered poets drank *café-crèmes* to keep warm. Seedy youngish men with exploded hair wrote in smudged notebooks. When they looked up, which they did rather often, they did not see you. When they looked down again, their pencils scribbled self-consciously. Sometimes they were joined by girls in heavy makeup and thin jackets.

According to street names we were in a city of saints with an occasional profane. The rue Guillaume Apollinaire was a subject of much jesting among literary buffs and artists who would point out to you its doll-like length occupied by two massive gray buildings *sans* numbers, *sans* entrances, these being located around the corners on its two busy right-angle streets. You could *walk* on the rue Guillaume Apollinaire but you could not *live* there. Max said Apollinaire would have laughed and loved his phantom street. In any case, he soon had to lie back in his tomb. The subject was so unmercifully taken

up and elaborated in disrespectful sheets like *Le Canard En-chaîné* that a few years later the city fathers got busy when no one was looking and had a couple of doors punched in the side of their building—it belonged to the town—and numbers conspicuously added to dress them up.

Now, with the slow tread of this summer night, memory serves me ill. Try, try to remember at least some of the thirty-four times three hundred and sixty-five nights. They are the ones to be cherished. Try, try to remember them and the same number of days to match, all shine and midnight blue, before they turn to black. For it is not always possible to notice when you are in orbit. Moments snowball to years. I watch them whirl around us with their processions and silences, their peripheral nebulae, famous and infamous, mortal and wistfully immortal.

Already winter. We are frozen in poses of doubt on the quai Saint-Michel. That pillar of yellow ice still clings to number thirteen. And in 1955 in Touraine—the garden of France they call it—we will soon dive into verdant fog to dig our second septic tank. Punctuated by measureless intervals filled with the stretch of passing lands, rivers, towns, mountains, craters, ruins, and walls, thousands of them, piles of stones; millions of stones that define every definable space; cut, uncut, crumbling, bombed, restored, blackened, and fainting in the carbon monoxide stealth that mocks the Stone Age, endangered species.

I am the perfect blotter. My eyes, ravenous monitors of lung and limb, never get enough of looking. Greedy tourist eyes, they tell me seeing is believing. The past is everywhere I turn, it will seduce the present if I am not careful. Frescoes tell incomparable stories, tapestries sign history in blue and blood and purple. A fortress sheds its anachronistic frown on the motel and gas pump below. Without clanking armor, tired limping horse, lice, suppurating wounds, I might all the same be seeking some absurd grail, so imbued am I, so annihilated by the evidence, so flattened against the martyred wall.

Moreover, tapestries are fragile and tend to fade. Captive

weavers must have known about that, weaving against time to break evil spells or to save their necks, in drafty stone chambers like this one at Angers. Here, trembling in a perpetual crepuscule, dreaming and indifferent to the ever-changing pairs of eyes that glide over them while the tour guide's voice drones through his dim spiel, apocalyptic episodes in pallid blues and beiges have lost their fire. Yet one pair of eyes, mine, is misty with looking at them. So old. So fragile. Their glorious days so long gone. It is perfectly thrilling to think of this lapse of time. Centuries come close because you are drawn in by standing there; you are part of the circle, the mystic signs are traced for you alone; the fanfare, dim but just audible, prods like the elbow of your neighbor craning to see.

Up and down the zigzag, weaving its own tangled tapestry, shuttled the *deux chevaux*, our steed. Open on my lap as Max drove, and providing food for thought, was the guidebook, indispensable bright red companion of timid travelers, carrying descriptions of every hotel *worth stopping in*, with petite line drawings of bathtub, toilet, telephone, bidet, a flowery little star if the food was deemed especially nice. Monuments, churches, curiosities sporting centuries of history were to be visited—between meals. Because clearly it was the restaurants that fascinated the guide-liners, pitiless compilers who graded food mills as schoolmasters grade student exams so that, given the guide's authority and the French penchant for rich and sophisticated eating, even the remotest three-star establishment received each day its quota of devout diners. Such "temples of gastronomy" were not to be taken lightly. In fact, entering one of these dining rooms at mealtime—you must observe the rigid time-slot in which you may be fed—was very much like entering one of the ancient churches on your itinerary: the same respectful silence, no one laughs or talks above a murmur (New Yorker, take note), the same soft beatific ministrations of acolyte-waiters who seemed to stifle an impulse to genuflect when uncovering your mystic nourishment, *la spécialité de la maison*, or pouring out the ritual splash of wine for *monsieur* to taste (why always him?).

In putting together his humble materials the starry cook in-

troduces a little bit of this, a little more of that, a handful of those things over there, a whisper of the other, until something decidedly odd yet palatable has been cooked and served. He has thus produced a secret which he guards as preciously as the old Prague alchemist kept his gold-making formula from leaking to the ears of his rivals. It is the eating *experience* that looms large on the road. Cars are driven from restaurant to restaurant, ports leading all the way to the Mediterranean Sea.

On we went, always south save for small deviations—Tournus, Albi, Hauterives where a postman had left his dream palace (*vaut le détour*, says the smart guidebook). Coastal barrens and folded flat lands crushed by immense cloud dramas that were somehow always unsmiling if not actually tragic filled the eye's frame, with only a rim of earth to anchor it to our concept of gravity.

The Losère, France's wasteland, raised its steep hills to bear an occasional ruin: stony wind-lashed manor or gaping chapel, abandoned by God and man, epitome of loneliness? No. Earth is earth, the sky is kind and this manor can live again. Surely we could replace windows and doors. They would be painted blue, of course, to match a clear day. There would be smoke from the chimneys. There would be trees. We would find water, yes, if you are determined. . . . Three or four trees on the leeward side. Oh let me stay, let me live in this place! I could make it breathe again. But no. Look back. It is still there, with its howling holes for windows, small now, and then a speck only.

White mountains like party hats rear at our left, grading to blue and then green, from cruel to kindly they come down to us to envelope the precarious wing of road that offers a bottomless plunge on one side and lo! a cottage on the other. Enough to set the mind on mountainside dreaming, each cottage beckons, You there, come in. Here is a cake to bite, and a convex mirror. And then each time, we are around the bend, we dip to lose sight of it with a stab of regret, something like abandoning a faithful dog. Yesterday, beside a stream, the black granite stones of a waterside mill asked me to stay. Take me.

Tooling south, we pulled up one day toward noon in Saint-

Martin-d'Ardèche. The usual village square, the same patchy high houses, the cat in the wide-open window, four crusty *boule*-players in a torpid slow-motion game, baggy corduroys lopped off at the ankle, patina of the *béret* that literally clings, an integral part of the head; always the hurrying dog with clearly some place to go, crossing the line of roll so that the player must wait, only a weary *merde* escaping his preoccupation. The same scene, a *cinéma cliché*, at every town. And always the deafening cicada din muffles the click of steel *boules*. Plane trees show their knotty roots and knottier branches in perfect harmony with the knotty, arthritic, hobbling citizenry: grandmothers and grandfathers and great-uncles and maiden aunts of restless beauties and ambitious boys gone to the city. What youth hovers there does so as absently, as lightly as the migrating bird.

Before the hotel lunch under green leaves: *"Tiens! C'est M'sieur Max!"* marvels an old waiter who is still here. *"Salut, M'sieu' la gazette,"* teases Max, and with reason. For the garrulous old fellow fills us in: the crook who had confiscated Max's house in the confusion of its foreigner's wartime plight is now behind bars, so the waiter tells us. For obscure crimes, something to do with pimping on a grand scale. "It's still yours, *M'sieu' Max*, you have only to take it to court." He does not know, as so many were to know to their satisfaction, that Max does not go to court. For anything whatever. We climb up the stony lane that serves as a road to the house.

At first I do not like it. A stern silhouette. *Tiens*, so that's it. There is something grim and harsh about its grayish walls, aslant and holed with narrow eyelike windows, rather too serviceable-looking for all its haphazard angles and additions, and denoting in the frown it presented to my eyes some long commitment to expediency. A mill? An oil press? No one lives there.

Surely he would feel some special acuteness in this place, would show me, along with the house, and however obscurely, at least by a silence, a queer change of tone, or just a translucent gaze, some glimpse of inner disarray, huddled inside him like a folded ghost. So that climbing the hill to his house (for was it not still and always, now and forever, his house?) would

be heavy going, a fraught, dogged pursuit of demons that he was determined to meet head-on. Oh, it was indeed for me, the whole detour. To show me the house, a place, as I soon saw, of indescribable wonderment. I had expected a certain postcard picturesqueness combined, of course, with the natural bounty of olive grove and vineyard, a few sheep on the hillside; I was prepared for that. But not for the magisterial presence of its totems. Max's totems in cement, iron, plaster. From every parapet, every stair ramp, doorway and wall, they leaned over me like a tribal council, sizing me up, I felt, to my disadvantage. (I am here. This is not a story.)

We move nearer the house, silent save for an exchange of *bonjours* with two urchins playing on the porch and who run down the hill as we walk into a garden room, almost under the house, a lower level. Its stone interior is vaulted, and there is the usual moldy smell that quite suddenly becomes part of a strange dreamlike moment in which I see at the far end of the room a dense, high forest, black in the penumbral cave where all is now very quiet, the children's voices gone, even the cicadas having momentarily stopped their eternal rubbing as they will sometimes do.

"This," says Max with a kind of gesture. He turns away and I go nearer.

It is then that the picture shows me its tattered edge peeling from the wall. I pull, only a little. The canvas clings to my hand. Obeying some sort of righteous impulse that needs no question, gripped by a swarming rage at seeing the paint flakes on the floor, intent, determined, I pull and roll, while he looks on saying nothing, nothing at all, as the picture is finally, no, not finally but immediately rolled in my grasp and I am running down the lane where, overtaking me, Max says it is too late to save the paint film in any case. But his voice is in pieces, lost in some neighbor's machine saw roar while a yelping dog that I know is on a chain somewhere half-menaces, half-cries, and a quick succession of hot gusts tear at my crazy burden, tipping me and blowing Max's white hair.

The rest of its history may be told in a few words: for two years it waited in friend George's *château* in windy Ucel. Then, when studio space was ready in Huismes (1956) it was

rebacked and brought home where for a season Max entirely repainted his forest, visited it with birds of dazzling plumage and rode a watery moon over the trees. Was it the black forest of his German boyhood? Or the stunning memory of America's Northwest? Whatever the reason, *A Moment of Calm* was truer than ever. "There!" he said, standing back. "It's yours." A strange and perfect moment.

1953–54 . . . France for a year or two alternates with desperate returns to Arizona. It was on one of those lavish meanders through the wide American rainbow that arches across states (we mapped a different itinerary each time) that we came one day to a windy crossroad in the New Mexico desert. A sign pointed: ACOMA, Indian Pueblo, forty-seven miles. Should we? We did. Those miles were slow and antic with bumps, holes, the washboard surface, if you could call it a surface, that marked all roads in Indian reservations and that were rarely negotiated without groans and coughs by any but the toughest vehicles.

Heedless travelers in low-swung city cars drive their delicate steeds onto beds of stone and stratum. So that by the time you have arrived at Acoma, high, high up on an unearthly mesa, the radiator is boiling, the sun is slanting across from another constellation, and you have somewhat lost contact with your planet.

"The first thing we saw," said Max afterwards, "was a church." True. It dominated the place, rising on the empty flat clearing like a lighted candle in the full face of the sun. There was no sign of life, no one at all. Cameraless, Max was nonetheless wistful. He stood gazing in disbelief. "Imagine! A Catholic church in a pueblo!" While we were taking it in, the raw adobe of houses and pink belfry, the empty square, a priest in black habit came out of the church accompanied by a small boy. They stopped to speak for a moment and then separated, the boy moving in our direction. "Hello," said Max. "I didn't know you were Christians here." "Oh, no," the lad replied, "we aren't. We are Catholics. Over there," he pointed westward to a neighboring mesa, "they are Christians, they dance without masks. Here we dance with masks. We are

Catholics." He smiled suddenly. "Want to see a dance?" Oh, yes! "That will be a dollar." He had a no-nonsense business-like air. Would there really be a dance? Now? "Yes, yes, they're getting ready in the kiva." True to his words, the place soon filled with masked dancers and their tribesmen. Onto the dusty agora, adobe houses spilled dogs, silent mothers, children, the old and lame. And in the last flames of a superb sunset we watched a dance that, as Max noted, was neither Christian nor Catholic.

The ocean liners that carried us across the Atlantic—four, six, seven times—are blurred into one. Always back to the little house, always away again, anticipating grace.

Each time we climbed the gangplank, forward-leaning into the slanting ramp, in the highest possible state of excitement (what other mode of travel can compare with the boarding of a ship?), shedding as we did so all imminent threats to our peace, we knew that *outward bound* was in the delicious here and now. For six days we rocked beyond the reach of friend and foe alike. Time then was a big lazy eternity, round as a ball with spume and spray, always in front and behind us, a benign amphibian not terrifying after all. It did not care how long you took for your next chess move. Until, unperceived and most wonderful of all, eternity drifted off into the mist, and it was landing day, bringing another kind of euphoria, other eternities to claim their due in exchange for their mansions.

There are frequent failed summers in Paris weather; autumn approaches while you are waiting for *la canicule*, the heatwave that passes you by. American summers of curling temperatures in league with a pounding sun cannot be expected in this rather northern austerity that doesn't sweat under its arms or leave its sweater at home. A good season, however, will bring such days of blissful blue and gold that the only place to be is out.

It was on such a day that the bus took me on at the place Saint-Michel. I carried a small flat package under my arm, a picture, a *forêt* by Max that I had long wanted to have framed;

now was the time. The bus lumbered, lurched, leapt, and dropped me at the place Saint-Germain-des-Prés. One of those days with summer balancing just above the rooftops, not quite coming down to warm us, and I hurrying up the street until a heart arrest, a complete turnover that shook my chest and brought me to a standstill. The little package was still in the bus, alone on the seat. For how long?

I watched the crazy monster tooling away up the rue de Rennes utterly unmindful of my package and of me standing upright in the street among crowds of people, none of whom I knew. Go after it, take the next bus, which would probably veer off in some idiotic direction as buses are wont to do. Report it? To whom? Where? How to find the number? And what was the use? My picture would be picked up, had already been picked up, a package is always fun, didn't we know it, a mystery, a stroke of luck, who knows? All these futile workings of the mind just as the decapitated fowl or landed fish pursues its useless jerkings before giving up. Moreover the disappearing bus had now a positively guilty look, running away like that with my package, its very outline the silhouette of a clumsy thief. There was something sickening about it like bad news from the doctor. One thing was hideously sure: my little forest wasn't mine any more.

Max had been pleased the day he gave it to me, a sunny moment of the kind possible only during the flutter of a gift. Oh, don't panic. Oh God.

Probably I walked on, probably the day went by, not so very blue, not so very golden after all, its fabric tarnished and a growing hole in it through which I saw a little phantom forest that would have to be mentioned that evening, a nasty confession. Disagreeable, surely, an evening destined to scorn and disgust, why not? How could I expect anything else? How not to agree with him?

In the shop windows I saw myself as one-dimensional, flat, without substance in a waver of bungling loss. Another wrong turn. Irredeemable. Could it be otherwise?

Yes, it was otherwise. That evening, laying aside *Le Monde*, he listened in silence. Then, after a pause, not at all exasper-

ated at being told something unpleasant, he said, mildly and very offhand, "Never mind. I'll make you another one."

Soon there is Venice. The incomparable. The mere name is enough, like a mask over a smile. It is a lacy word that, if you're going there, promises you certain reward; indeed, the one place on earth that is absolutely predictable. Here behind heart-catching facades, their filmy reflections fluttering in the dirty canal like fragile altar cloths hung out to dry, lie all the secrets you could wish for. Here filthy water is beautiful. Here all rooms are lofty and the worms in the walls have no more work ethic than the gondoliers. They wait while we wander.

Of course you don't really believe in the people who are put there, or the dogs and cats, like those tiny dolls on architectural models just to show the scale, because the real Venetianos throng the Carpaccios in the museums, promising to come back soon (tonight?) from their long vacation.

This was the Venice Biennale, 1954, in those days still an event. We were assigned a princely hotel room, golden chairs, royal weight of bed, a funny telephone, damask walls. Our two dogs were not overly impressed, being concerned with the menu. On the second day the waiter at the door made suggestions. But I said no, he would please bring carrots, rice, and meat. It was really what they wanted. Dogs do not hold with the habit of change in these matters. But the waiter's eyebrows lifted and he said, "But, madam, they had carrots yesterday!"

Unashamed sightseeing, museums and palaces, streets, canals. Back at the hotel a telegram, "Max Ernst: You have won first prize in painting. (Arp for sculpture, Miró for graphics.) Please come to the Giardini at eleven tomorrow."

Next morning, arriving at the gate, guarded by two splendid *bersaglieri* in white and gold, we are stopped. Oh, Max! He has forgotten his telegram. He rummages in his pockets, a key chain in the shape of an owl falling in the sandy path. As he recovers it, he is trying vainly to communicate with the magnifi-

cent guards, Italian being a language neither of us can deal with. Gestures. "But we are invited," pointing to the distant crowd. "We forgot. I forgot it at the hotel. Danieli. Hotel Danieli."

Here a few mysterious words from the guard, with negative shake of the head and a finger pointing to the town.

"But it is too late to go back. Don't you hear, the ceremony has already begun." We hear the distant applause, the loud-speaker. Adamantine, the beautiful *bersaglieri*. A last effort: "*Ma sono primo premio*," pleads Max, touching his chest. The handsome soldier stares. There is a short staring moment while he considers this staggering pronouncement. Then he steps aside to his colleague where we cannot hear. But we see his all-too-plain gesticulations: right hand raised to point with index to his temple, the finger describing a circular motion. *Primo premio*, shapes his disdainful mustachioed lips, as his pal rolls his eyes to heaven. Frowning, he returns to invite us to the exit.

So we did not after all bask in glory, Max's *primo premio*; he did not, except in laughing, even refer to it, while we dipped instead into Venice's older glories, and in the darksome nave of a cool church peered squinting at the great shadowy Tintoret-tos, loving them without quite making them out—they could be fakes for all we knew but it wouldn't have mattered. Not on this day. For the reference and the moment combined to pro-vide enchantment of a very superior kind, we said, to what was droning on under the sultry wet sun in the Giardini. Some who had been there said afterward that no names of lau-reates had been pronounced to dim the grandeur of speeches that exalted not modern art but their own city.

The first American to win the big prize. Its concrete results were twofold: banishment (exclusion) by Breton and his new friends from the surrealist enclave, for so stooping. And the money to buy a farmhouse in Touraine.

But alas, an American not for long. Once more we are back in Arizona. Once more involved with lawyers, and writing darling letters to congressmen who just might see the gro-tesque error of the McCarran Act. It was McCarthy time, and Max was a naturalized American; as such, somewhat second

class and certainly not permitted, like the rest of us, to stay in a foreign country. A familiar refrain, it must have seemed to him, sung in three languages so far, and always off key. Knowing that indignation would be sterile, ah, but patience rewarded surely, our hope ran high. Did we not have a fancy lawyer who had literally promised? Had not exception already been made for von Stroheim, the moviemaker? Could not an artist, a *primo premio*, expect the same? After sixteen humiliating months of dreadful effort, trips to Phoenix, money running out, a decision had to be faced. The pictures did not find buyers enough to keep us. So we gave away our crooked little house, built with Max's hands, and returned to commitments in Paris. It was spring 1957.

Money. A brand-new commodity after the Venice event. It had begun to roll in, I believe is the fine, opulent expression, and Max was soon accustomed to walking around with cozily bulging pockets (French bills being big as flags, tastefully tinted and bulky). Many days saw him presiding at the bountiful tables of three-star restaurants, treating with the chummy new money his less fortunate cronies, *bons vivants* all, to those monstrous gourmet meals that last for hours while the talk flies and the wines flow.

At last it is time to pay the bill. He reaches into a back pocket for crumpled paper notes, some of which fall on the floor like dried leaves. He peels one off and stuffs back the rest, all very slowly, absently, into his hip pocket, perhaps finishing the anecdote while *convives* struggle to their feet, all laughing and talking at once.

It is then that the waiter runs after him, flushed, proud of his shining honesty, waving a bank note.

"M'sieur Max! You dropped this. It was under the table."

Max turns, quiet, embarrassed, vexed. Accepts the object with a careless air of disdain and indifference that says, Why did the fool have to spoil my fun? Showing me up. Making me awkward, ridiculous. I hate this.

No one likes to be caught doing something wrong. I believe he would have preferred less zealous, yes, less honest waiters, for it happened more than once to quash the gaiety if only for a

moment. There is something terribly sobering about a bank-note on the floor.

At one point in the game of addresses we bought an apart-ment, a Paris *pied-à-terre* that was really the second (top) floor of a small house in the fifteenth *arrondissement*, a most unfash-ionable quarter. Max peeked into the attic, a kind of crawl-space. Could he buy it too? "You can have it" was the amazing answer. Work then began, it would be a studio; architect, plumbers, carpenters, the usual bills, the familiar struggle to keep track of the contractor.

Oh, but it was worth it: the roof raised on the north side to make way for light; smooth pale floor, banks of drawers under the eaves. A proper studio, reached by our very own stairs, where he was soon at work as if nothing could happen to inter-rupt the steady flow of exhilaration.

Exhilaration's underside however does not take long to tinge our bower with, first, unease, then anguish. We heard it one night when awake at four-thirty in the morning—the sound of horses' hooves on the pavement outside in the rue Dutot. It al-ways happened at the same hour: I would be torn from sleep by the bright, rhythmic clop-clop, I would hear with excru-ciating clarity the jaunty steps of unseen horses, obedient and all-unknowing, trotting nicely through the hushed sleepy streets, breathing in sharp morning air and exhaling snorts of rumination, perhaps liking the smart sound of their hooves on the cobbles as they walked to the *abattoir* (slaughterhouse) a short mile away. Again and again I told myself that they were oblivious of their doom. But how to accept it?

Until one day release came in the form of a knock at the door and two *messieurs* who floored me with the news that we had six months to remove ourselves. Ah yes, the house was slated for razing. "But this cannot be! Indeed, it is ours," I told them. "Madam, you must have known. All property owners were notified. Repeatedly. Why, here is the decree. The sector has been on the demolition program for eight years." A stun-ning revelation. It was one year after *les travaux*. Shaken but unvanquished, we moved to the country where new *travaux* lay in wait.

VII Another Garden

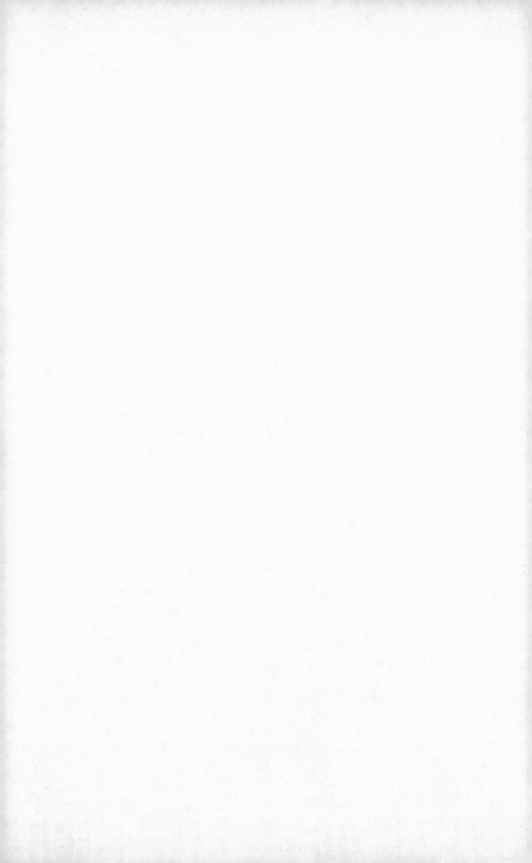

Huismes, Indre *et* Loire, is in Touraine and has long been called "the garden of France." Creamy stone punctuates the all-over green fief of ancient kings and modern Americans, two of whom led us to this house not far from friend Sandy Calder. We readied it, saw it fitted up with plumbing; we scraped and plastered and windowed, stairwayed, heated, gardened and walled. Into this house that we called Le Pin Perdu (it had been Le Pin, but no pine tree was to be seen) came everything we owned. Six thousand miles of land and ocean were traversed by our fantasies and foibles, further swollen by more of the same found locally.

The houses we have made! That we have feathered, floored, furnished. The flea markets we have drawn from, the antique fairs, the *brocante* (junk) not old enough, just too old. Each time believing it was the last and each time moving on, our gear a growing mountain in spite of doleful losses. These pare our history to just this side of amputation.

Letters, photographs, books, objects, even documents, big and little things treasured like breath—impossible to live without them—move with me and the beds and the casseroles from house to house like an oxygen tank that has seen better days. In this way a diminishment at each upheaval (that photo there, why has it only one eye imitating a windy tunnel?) hints at loss. A little lost each time, not much, absorbed into the mysterious space to which you willingly confide pieces of your reckless life, your memory deeply troubled and faulty without them. Because even the skeleton can lose its key like that of the last house, and upon what bones then can you hang your folly? After a while I could not remember what I didn't have anymore.

In Huismes, down at the far end of the garden where the sky held a sweep of dominion over a small unshaded territory, we

built a greenhouse for the provision of potted flowers to bring in during the long winter spans and for starting (we would beat Monsieur Blondeau our neighbor by at least three weeks) early lettuces and tomatoes and basil. In this greenhouse puttered and pottered our dapper old gardener, Monsieur D., *béret* aslant, clipped mustache and *sabots*, who regularly wore a knitted vest from the busy needles of his invisible Madame D. —we never in all the years he was on the place laid eyes on Madame D. and with reason. For, when coming back, unexpectedly, one soft May afternoon from a stay in town and after ringing at the gate a rather long time, we were admitted by a beet red Yvette, our housekeeper, and glimpsed at the same moment Monsieur D., issuing from our ground-floor bedroom down at the far end of the house, arranging his baggy corduroys. So the knitting needles belonged to Yvette, just as did the gentle May afternoons. And to think we always called him old Monsieur D.!

For eighteen years this Yvette held our daily life together. Widowed early on, she had raised four daughters from scratch. Scratch because it was hand to mouth, a factory job. Until on a dim day her boss disappeared, with three months' back salaries. Thus we inherited Yvette. What she did for eighteen years is a litany that could interest no one anymore. But the armloads of flowers from the garden and her thin voice, so at odds with the solid body, as she answered our compliments, "*Oui, on dirait de fausses fleurs.*" ("Yes, one could mistake them for artificial flowers.") Or telling of her brother who had drawn a dog so lifelike that "*On dirait qu'il allait parler.*" ("You'd think he was about to speak.")

Joining in our occasional foolishness—dinner sometimes saw us all gravely costumed and unrecognizable—into a wicker trunk of rags and jetsam she would dive with the rest of us, to come up with the colors of our evening. Decked out in fireman's casque and black lace knickers this hard-working Yvette served the ragout, attentive and unperturbed. To see her bouncing down the lane on her *mobylette*—the wide expanse of her girdled behind forming just one firm imposing cheek miraculously and, you could perfectly see, comfortably resting on the little triangular seat, a long loaf of bread

strapped just under it—was a sight to either distress or amuse, depending on who was watching.

It was a stunning event when Yvette won a Solex motorbike in a farm journal contest. The contest: Guess the Correct Age of This Dog (fuzzy photo). I could imagine them leaning together on her oilcloth table-cover. Evening. Monsieur D. argues for his guess, then when all agree and it is settled he gives it to her, to his lady, his first guess. Because he sent one too, in his own name. They wait. The farmers of the whole French nation are waiting; every *paysan* has guessed the age of the dog. Then a telegram for Yvette. Stupefaction! She has won first prize, the Solex. And he, Monsieur D. amazingly, wins the second, a shotgun. After the excitement he asks would she, Yvette, trade? Would she give up the Solex for the gun? After all, she already has a motorbike? Ah, no!

He was a sort of intellectual or thinking man, this Monsieur D.; he read the *Canard Enchaîné* but kept his ideas and his opinions to himself. In fact he was not a *casse-pied*, or talker, at all. He trundled his wheelbarrow of manure down the nave of our garden path as if it were an offering of lilies to be consecrated at the chancel. On rainy days he stayed in the greenhouse, that hotbed of optimism as redolent of green buzzing life as the shores of a pond. In March it was a moving thing to watch the seedlings push up in their slats, first showing their bent pale necks like tiny wickets and the next day pulling the rest of themselves out of the mysterious dirt. Max wanted nasturtiums, happy flowers, happy to bloom, happy to be eaten in the salad. But all too soon their glassy prison, like so many prisons, went wild and wrong. April, May. By June it would be almost impossible for Monsieur D. to get through the door, so choked it was with rampant verdure grimly waiting to be set outdoors. The chlorophyll was overwhelming. Unwatered pots began to line up around the outside walls like garbage cans, hoping only for invisibility, waiting for oblivion. Compost, he told us, it would all make fine compost. As for the transplanting, it had rained too much. Or it had not rained enough, the ground was hard. You can always count on one or the other. Monsieur D., like the sorcerer's apprentice, had each year started something he couldn't finish.

We respected his thinking life, how can you help it, con-

fronted with such dignity, such mystery? It was Yvette who brought it all together, she whose brother had been carted off to God knows what concentration camp, along with the rest of the vigorous males of Huismes, resistants all, never to be seen again. Denounced they were, by a slimy local *collabo*, someone with a "de" to his name, the town's *grand bourgeois*. She told it with fatal simplicity. The *collabo* had stayed up there in his moldy *manoir*, doing for himself, she emphasized, because certainly no one would work for him. After the Allied victory he was dragged like a rat from his walled garden to the village square to be judged and shot.

Yvette sighs. "But when the time came, *eh bien*, no one in that crowd would hold the gun. We were all together, maybe a hundred widows and old people. None of us wanted to be the one. So he is still up there in his house. *"Et il y a même ceux qui lui disent bonjour."* ("And there are even those who speak to him.")

There are certain modest luxuries which, taken all together, make a small life big: letting a day go by or even several before answering a letter; saying one isn't at home; telling the best ideas to a dog; crying for fun. No matter what happens we are on the inside looking out.

Back in Huismes in 1955 after Venice and the *primo premio*. It was about this time that a certain quantity of letters began to arrive in the mail for Max. Intense, shy, yearning letters. With their terrifying hints at deep understanding buried in shallow beds under the polite loam of unqualified admiration and, deeper, of that febrile longing so ready to germinate with the least encouragement, these letter writers would be grateful for a word, a sign, a photograph, yes, one would almost say a fingernail cutting, if it wouldn't be too much trouble.

All this I had to see when his desk shuddered under the weight of tools, books, random open tubes of drying paint, pens in long-dried-out comas, reviews, forgotten letters, even some sort of prize, a check that it was years too late to cash. Periodically something would have to be found. The compost had to be disturbed, smeared around, fluffed up, and eventually swept; a little order would take the desk top by storm, and there would appear a chink of wood surface, a rift to be plugged by new arrivals, among them those life-breathing let-

ters from friends which, after being read and their contents fondly noted, got dropped in a wastebasket. And he, without a thought in his head for personal history and the chain of events that is not a chain at all but a tangle of string under busy fingers pulling and twisting and unknotting it to find a piece that will tie up a fiery day, a cold night.

We know a few literati who will persist in their sweet old lavender letter-writing habit, for which we bless them gratefully. But the scent rising from the letter is potpourri, anachronism in a world of telephones and tapes.

What then is to be said for a man who, after reading his precious letter, lets it fall where he happens to be, as a bird scatters the husk from the seed he swallows? Some of those friends must surely have assumed that the letter would be treasured on its piece of oh so fragile paper. For its mere existence. Or its intriguing oleography. Or, let's face it, its signature. But there! It is gone. And will never appear in the *Collected Letters of.*

Saved, he may have thought, from editor's scissors in any case, for editors are censors like mothers or heirs. These last do not thoroughly approve of their naughty relative in spite of his fame and the fortune he has provided them, all unwittingly; they are violently embarrassed by his outlandish ideas and infuriated by his apparent unawareness of their existence. So, at last, they can bring him to heel, albeit posthumously. Cut out those nasty phrases, keys to his shame. Yes, the least they can do is to keep the most offensive passages from the public. Sometimes, for instance, the fellow had grown up in poverty and even strife. This the children, brother or sister, now rich and respectable, *grâce à lui*, feel impelled to gloss over. So they invent for him a whole new past, as patently dreamed up as, say, his being borne toward shore on a conch shell, fully blown, incapable of dark thoughts.

It may also be said that from this time on, between letters and visits, life was never again the dreamy dawn of Sedona, Arizona. Our Pin Perdu opened its pale blue gate to admit a fairly steady procession of every sort of visitor, from the bosom friend to the merely curious, from the personnage in his long car to the postgraduate with backpack, from the collaborator (book, theater piece, exhibition, *estampe*) to the bearer of mes-

sages from home. An American *mécène* broke bread with our Swiss carpenter. An orphan housemaid from Paris posed with Man Ray, our American photographer. Chess was played for two days nonstop with two Duchamps.

One day, to match a moment's levity, I showed Marcel our *Mona Lisa*, a handpainted copy, actual size, that had been a mock "prize" for Max at a party. Here she was, a sinewy, all-wrong creature, powerfully painted on a wooden panel, her crooked leer a categorical repudiation of all artists including Leonardo da Vinci. "All she needs is a mustache," I said, to prolong the fun. Duchamp: "Well, give me two small brushes and a little white and raw umber." That afternoon our *Mona Lisa* became a masterpiece after all, for he painted every hair of mustache and goatee, just as he had on his famous original. Another golden moment.

People will nearly always let themselves be photographed. If some eccentric groups, like the Hopi indians, outlaw our cameras it is only because they are *primitive*. Civilized people do not mind at all. In fact, seeing that round black snout turned upon them they can't suppress an involuntary expression of contentment as if somebody had just pinned a medal on them. They often pretend not to notice. But it gives them a moment of bliss.

"Do you take real pictures? Is there film in the camera?"

"Nearly always," I reply, unwisely. Because one day, on the terrace it was, with a brace of rollicking callers, two directors of something artistic or other who with guffaws and chortles had donned flowered straw hats for the photo, a bad moment occurred when I discovered there was no film in the box. My sitters did not hide their disgust when I (oh so stupidly) announced the funny discovery; peevish and sarcastic they hardly spoke to me when making their farewells.

Never was a man so solicited to return "home." *Bitte*! Visitors, authors, interviewers, filmmakers hopelessly tangling my house for days, weeks. Droll souvenirs, recited poems (seductive, indeed, those lines from Bürger, Hölderlin, Novalis. . .), rousing school songs. Old cities showered him with new honors accompanied by medals and colored ribbons. They in-

stalled a Max Ernst fountain in his home town of Brühl; they named a *lycée* after him. Commemorative coins for his birthdays. A bronze plaque on his birthplace. And needless to say retrospective exhibitions to which we traveled. Naturally. Assiduities I had come to accept ruefully, wonderingly. Oh, the good people I have tried to communicate with. Their boundless love and admiration for him and therefore his wife. They coddled me, cooed over me. "Just imagine, she paints too!" And I, to myself, more and more frantically, "I have learned the wrong language."

February 8, 1959. In the kitchen of Le Pin Perdu, our world, Max opens champagne, a fire is crackling in the big chimney, and nobody cares that outdoors is dark and wet at five o'clock. Monsieur D. has stepped inside in his stocking feet, *sabots* left by the door. Yvette turns down the gas under her *poireaux* and comes to take her glass. They both hold the stems delicately, little fingers aloft. We are just four, and we drink to Max, French citizen from this day forward. Stateless for a year he had gravely accepted when the *premier ministre* said: "France would be honored. . . ." So now at last he has a home. As for me, sadly glad would be the word. Moreover, I find irresistible an impulse to include here a final document, received in 1964, five years too late:

EMBASSY
OF THE
UNITED STATES OF AMERICA

American Embassy
Paris, France
July 20, 1964

Mr. Max Ernst
19, rue de Lille
Paris, 7^e

Dear Max:
 As you undoubtedly know, the Supreme Court on May 19 ruled unconstitutional Section 352 of the Immigration and Nationality Act (and similar Sections under previous legisla-

tion). Thus, naturalized citizens now have the same rights and privileges as native-born Americans and may reside abroad indefinitely, whether in their country of origin or elsewhere, without endangering their American citizenship.

Furthermore, decisions on loss of citizenship based on that Section are thereby voided. It gives me great pleasure, therefore, to tell you that if you wish to verify your continued United States citizenship, to receive a passport, or to register as an American citizen, I shall be delighted to see you. Please telephone me whenever it is convenient for you, and I shall see to it that you are given prompt attention at any time that you would care to come. I don't think I need to tell you how happy I am personally to be writing you this letter and I hope to have the pleasure of seeing you and Mrs. Ernst again.

With kindest personal regards,
 Sincerely,
 Perry Culley
 American Consul General

Oh, too late, too late.

To have consciously turned away from his country at an early age after having worn, willy-nilly, its military uniform in the world's most lethal war and to have recognized its ugly destiny during the slow approach of further madness must have been for him an abiding horror. And then to become again a victim of that same horror along with millions of surprised and helpless human beings; all this must have demanded of him an unshakable faith in art as salvation. His own art, certainly, along with that of the others who did not survive the horde. (That, too, he had painted, *La Horde*, over and over in those menacing years.)

On the flagstones under the wisteria, sunspots are small and round to match the ones on the table. The soup steams in the shade. A glassy sort of hour, fragmentary talk in this rolling,

bowling language I do not understand. Some small argument, desultory, an argument as blurry as a warm snowy day when the words are quick to melt. Oh Max, you are so reckless with your foreign language in plain view and your hair blowing over one ear. The sun has gone and gusty wind takes over. I bleat a verb from time to time, unexotic. What am I doing here?

You look to me for rescue and I say let's go inside for the coffee and this we all do. The tiny argument has melted, a puddle on the table outside along with crumpled napkins. Coffee is sipped in silence because you are all at once a statue, your eyes are turned to the ceiling, you are a million miles away and you will not come back. For the thousandth time I leap; the breach is filled with trusty amenities dredged up out of old habit as you knew it would be, with smiles, gestures, sign language. It is nothing to what I would do for you, in truth. Just ask me.

At last they are gone, have waved goodbye. The next hour, spent cleaning up, bringing the threads back into their quiet basket, passes in that blessed time-slot known to those who emerge from anesthesia.

Mein Onkel Meine Tante und Meine Cousine
Das Leben ist Kein Traum . . .

But it was, it was. My love was so anchored, so final, that a wisp of regret sometimes swept over it, an odd little cloud: I would never know despair in love nor its varieties of revelation, love's pain would not be granted me. It was like the time I had wanted to be mad, not knowing my good fortune.

Max painted my portrait then, in his way. "Hell, I could die now," I thought, seeing it. But what can I say? I'm glad this did not happen.

Because of language confusion our shape as a pair was not five-dimensional. Or even four. What we shared was to the casual observer predominantly emotional and even primitive. But it was richer than that. *Sans* language. Or languages. Scary tools that in our hands became kindly as the years passed. We had wished so earnestly to make them so. High in color our lan-

guage, and often, oh very often, funny. We found we were able to adopt and adapt current or referent expressions to furnish conversation with everything we needed. We could give adequate well-shaped reasons for acceptance, rejection, admiration or indifference. We could fight respectably. Of course there were fights. Accusations, reasonable or unreasonable, it never matters. Without the anger—the crumpled hour, the clouds of adrenalin, the floods, the quiet gloom while it is going on—he couldn't eat, I couldn't think—our lake would have filled with grass.

What oral communication we had was quite good enough for our purposes and we had so much else. What's more, accents were a source of delight. My French had enough inadvertent clumsiness to amuse all present. (As an American I would never be able to say *truite* when ordering trout. With that one word, an enemy would easily unmask me. Treet? Tweet? We must choose.) His English was a treasure of funny words. Bushes and cushions rhymed with Russians. "Ah yes, Dorot*ay*a."

There hovered, however, a persistent, medium-sized cloud in this great wash of blue. Instead of crossing from one side of the bowl to the other, or rising or breaking up into samples of cloud, it stayed around to blur our edges and provide a little frustration. In the area of books, only the French ones were shared and those not always. There was no use pretending I could hear their nuances or savor their styles even though I could read *Bouvard et Pécuchet* with delight. For what was I to do with the wildly involuted prose of André Breton? Or Malcolm de Chazal's so very French maxims? I loved the gentle heart of Marcel Schwob, and the perverse extravagance of Villier's *Axel* is still a real peril to my precarious equilibrium. But the others, all the others. . . . How little time there is. How could I find enough of it to learn to read the German ones too?

Max lived in an ever-widening pond of books. There was not a day that failed to deliver its book, that did not see a new one float into view on eddies of mail (American), by hand (German), or by bookstore (French).

My own library was a smaller corner. In it those smoldering former companions, pushed aside like cast-off schoolmates,

slouched in the background and assumed the easy poses that only words can claim. They all knew their turn would come. The defiant American paperback with its peppery pinup cover that has nothing to do with the inside. As if anyone cared. All you have to do is tear it off. And the faded hardcovers, how had they managed to stay by, to turn into seasoned travelers, discreet and huddled where you could lay a hand on them?

My shelf. And then, very quietly, they began to appear among his. Their translations: *Jude the Obscure, Ulysses,* and *Moby Dick. Typee,* too, and *Mardi.* Hawthorne, Thoreau. . . . How, I wondered, would they translate Henry James? Ambrose Bierce, okay. Fitzgerald, okay. Henry Miller, I could see that all right. But Joyce? Good God. Yet they all slipped, gleeful masqueraders, into that other company and took their places graciously, like expatriates rather proud to be able to give the time of day in a foreign language.

The effect on me was stunning. My book friends were all at once new and naked. I was filled with amazement. He wanted, then, to know what I knew, read what I read? It was a startling thought. I felt oddly nervous and responsible. Random phrases from this or that book surfaced in my mind. How would they sound to him in French? How would he *see* them? The first real knowing of that part of our life was taking place at last.

As painters we must, I suppose, be counted among the profane, the ones out there; we are happy to gobble up whatever prose or poetry fills our needs, we have no thoughts to spare for the toiling syntax by its various creators. We can become fond of, nay, dependent on, Kafka who found our cracked mirror under the bed; we can gorge ourselves on Nabokov and sober up with Trollope. Céline makes us queasy, not the way he wanted to but because you cannot translate slang: And "over there" some readers will feel the same nausea for the same reasons, with impossible translations of untranslatable Americana.

Incidentally, if you have spent your life developing skills that have nothing to do with writing, it isn't likely that, should you have the crust to write a book, you are going to produce anything very skillful. Putting things into words instead of

pictures is as shaky for me as getting out on a stage and opening my mouth to recite a poem—something I was obliged to do as a child. No, don't think about it. You are in this too far to turn back. As the work progresses, for progress it surely must, in spite of the times when it seems to go backwards: the end is really the beginning, inside is out, round is full of cruel angles and loud is inaudible; the more I try for economy the more the wrong words crowd me and the more I realize there is little hope of *conveying* to anyone at all the quality of the times, the places. Hilarious events, wasted potentials; but truly, there must be a certain amount of recklessness.

Besides the bookshelf books there were the homemade ones. In the kind of life we led, bookmaking was as necessary a part of it as buttons on a coat. I cannot remember any painter acquaintance who did not at some time engage in collaboration on a book.

Editions were never more than 120 copies, or they depreciated in value as the numbers rose. Ardent publisher of some of the best of these was short, round, Swiss Monsieur Broder, whose demanding profession left him only time to eat, and it must not be assumed that he did so out of mere hunger. His obsession with *le beau livre* was juicily matched by his devotion to *la haute cuisine*. I am sure that in putting together his elegant books he considered himself a kind of superchef.

One day he asked rather casually, "What kind of books do you have in America?" "Oh, very good books," said Max. "But how are they made?" he wanted to know. "Who buys them?" I explained about how the book is generally hardcover, printed in many thousands, "and after they're read you put them on the shelf. . . ." "Oh!" Monsieur Broder did not disguise his scorn. "Oh, you mean they buy *reading* books!"

Texts often came from poet friends. Or there might be some long-forgotten manuscript to be brought gloriously to light, with Japan paper, elegant handset type, abundant fly-leaves and, most important, lovingly pulled etchings in limpid colors that melted into the petallike paper the way mauve and carmine soak into the sky at sunset.

Paris etcher *par excellence* was Georges Visat. With his tricks under control, his scumbles, acids, chemical wonders, coaxed

accidents, his waxes, varnishes, sugars, resists, spit and resins followed by hours of scrapings, polishings, inking, proofing—all the arduous passionate sweaty process of etching on copper, he brought out glorious deep-diving images in floated spectral colors for which other people got the credit. I suppose that's the way it should be. Artist, artisan. Both words obsolete in this context. As one of the first of the two I experimented with it all. Until it became clear to me that the process was so overwhelming, so fraught, it would be better to drop it instead of going crazy with the possibilities.

Constantly on the prowl for new techniques, Visat one day borrowed a little painting of mine and made from it an etching. It was perfect. But was it wrong? Was it a fraud? Would a collector find it a cheat? Would Georges Visat, with his special hands, his good-natured genius, his light under a bushel of artists, reap opprobrium for keeping the flame of etching alive? It is an interesting question. As the years passed Visat waded into editing, producing not only etchings but the whole book as well.

An interesting number of these books were fiercely and explicitly erotic, with rich descriptive passages and a wealth of invention. They were written by mild, overrefined men and women whose swollen imaginations doubtless consoled them for grim reality. Even such books were *built*, like cathedrals, with an inordinate amount of creative fervor and dedication. Erotic or not, emblems so strong in their collaborative ardor were bound to become objects of pure magic.

Such were the books made by Iliadz, another shoestring editor, with his artist and poet friends: bouquets of words printed with love to hold in your hands. For in pursuit of our goals some writing has always gone along with whatever was the abiding expression. A "free" sort of adventure, serious fun without the dedicated preparation, without the drudgery and without the least thought for what other people might find to say about it, should it ever see the light of print. If Artaud or Apollinaire—or Henry Miller or e.e. cummings—decided to draw or even paint, it was in a spirit as erratic and *irresponsible* as the capers of birds in air. They risked nothing. Here they were safe from judgment and misunderstanding quite as we vi-

sual artists were safe from stern eyes if we blithely wrote a sad poem in the sand. Such a poem surely can't be depended upon for anything, anything at all. Unless it be for our own tiny pleasure that can, and sometimes does, translate to tinny.

Another one of those Paris days, prismatic. A *rendez-vous* with Max. Arriving, he said, "There is an idol of yours at the café next door. Oppenheimer." A stunning announcement that suffused me with something like embarrassment, the beginning of an impulse to pretend disinterest; oh, with Max I was always on the lookout for irony. But he was not smiling this time as he went on, "Over there at the Deux Magots. He is sitting with a lady." Not to do something was for once unthinkable so that, quite shamelessly, I went to see, simply leaving the Flore to walk past the Deux Magots. Only to walk past. To indulge my eyes that they might eat, drink, and breathe this person who had changed the world and wished he hadn't. Let him stain the whole day, I rhapsodized. He would be an earthquake, a revolution, a northern lights. Seeing his blue eyes would. . . .

He is there, with his wife, blending in. Yet all is, finally, foreign: the passing people, the aproned waiter, the table, marble with brass rim. He is set down before it by a fabulous hazard that completes its bravado picture with a little glass of liquid for him to drink. On the marble table as on all the other tables crowding the sidewalk, are the glasses, one for him and one for her, blending in. What is he thinking behind his prestigious forehead? What awful certainties are perhaps spoiling his Parisian *apéritif*? Can he even, just for one exotic moment, assuage his thought, forget his terrible burden?

So as we walked through dappled shade and sun, we saw the man half rise from his chair behind the little table. "Max Ernst," he said, his beautiful face offered, the half-gesture, half-smile. It all came together in one perfect minute. The invitation, "Please—have something with us . . . my wife . . . only a few minutes ago we saw a painting of yours in a gallery, just over there." And Max, "Yes. I know, in the rue de Rennes."

By this time more chairs are drawn up and we too sit there.

They talk. I listen. My awe amounts to anguish. Their easy conversation does not help. Instead my scrambled thoughts plunge on alone.

Noticing perhaps my disarray, Oppenheimer addresses me: "What is that stone in your ring? It looks familiar." "Oh, it's nothing," I disparage my ring. "It's fake, a bauble, junk. A friend gave it to me." He looks again. "But I think you are wrong to call it junk," I hear him say. "You see when I was a little boy I collected minerals. And this, if I am not mistaken, is a kunzite. It is mined in southern California around San Diego. Yes, it's a real stone and even a very good one!"

As my hand writes of that day it wears the ring, the kunzite, and all kinds of reflections shaft out from the pink stone. I am remembering the evening when I first admired it, even the name of the restaurant, and my friend, its wearer, taking it off and handing it to me, a rare kind of gesture, something like a butterfly alighting on my hand. I protest: "It's too. . . ." And she: "No, no, I insist, you must have it," neither of us knowing anything about its name, its San Diego, only enjoying the give and take moment, the *pinkness*. So that Robert Oppenheimer, father of the A-bomb as he was called by the media, could forget for a moment his place in the dreadful present and remember "when I was a little boy," a pink stone had to sparkle in the sun on the boulevard Saint-Germain.

VIII *A Provençal Domaine*

But this is 1965 and we have left Touraine, left the tarny mists of Huismes, left the green mold that hid in Max's shoes, more of it streaking up the bedroom walls, fast-growing pet of mother nature with roots under the tile floor. Now we are *Provençaux*, as sun-ripened as figs. Seillans, our home from now on.

Twenty years ago, there was the hill in Arizona. Capricorn Hill it was then. Another hill was now, older or perhaps not older, in another part of the world, another land mass. Olives instead of junipers, scrub oak instead of cactus. Viewed daily and with longing from the venerable windows of our village house, from behind tall cypresses imitating furled black umbrellas. No road, only the worn meanders of a rugged shepherd who actually brought his flock through the village to where—hop—they all swarmed off the road and up on the hill, his two busy dogs directing operations as smartly as any traffic cop.

We, with our covetous eyes, were the living symbols of encroaching modernity. Did we not act to dispossess the good shepherd (at least to spoil his afternoons); did we not run rough-shod over the innocent sheep, send them packing to graze elsewhere? We with our big ideas, standing on the hill with the village below, a burnished *pâté* of huddled stones and rosy roofs whose geometries melted together like a benign puzzle presided over by the usual *château*, in this case a massive fortress reared against Saracens. Beyond the village stretched a ribbon of road winding between ever bluer distances leading to the sea, the entire panorama presenting a quite happy facsimile of those naive illuminations in ancient manuscripts. It happened later that I sometimes watched the ribbon anxiously, when Max had gone off for errands in Draguignan or Saint-Raphaël.

It was easy to acquire the pretty hill. With Monsieur E., its part owner, we soon "came to terms," as the saying goes. Modernity was there before us, lurking in the desires of village descendants of Moslems and Romans, Phoenicians and Visigoths. Families of innumerable cousins who had not spoken to each other for years, inheriting the precious hillside from ancient grandfathers and grandmothers of grandfathers, desiring instead automobiles and television sets, appeared at the lawyer's office in sullen silence, signed, collected and left, never to be seen by us again.

Next day we stood up there looking down. It was ours now, henceforth our anchor and our view. So began the The House.

For a year there was only the rumble of bulldozers on the hillside. They tore and gouged the gaping, gasping earth, its drowsy stones disturbed and dumped along with their paleo-dreams and dreamy names: Cambrian, Silurian, Devonian. Creation's hill had to be wrenched around, leveled, filled, sounded, reinforced where there had been nothing. All we wanted: just a small place on the ground to receive the house, its implantation, as the geologist called it.

A kind of yellow sunshine is on hand though it is winter 1967. A woman on leave from her canvas and paint bends instead over plans, a different sort of drawing, all straight and true, minutely measured, with logic of doorways and floors and stairway and stress. The stairway would lead to a "ballroom" (see above, "big ideas"—why lose sight of festivity?). The rest, all of it, to be on the ground. So that from his studio, a wide lofty studio at last, smooth marble floors would bear Max across to everything our imminent *domaine* would comprise: the columned arcades, the library, the wide hall, the keyhole pool, the garden terrace blooming with dendritic traceries on flagstones that we all want to think are ancient ferns.

Looking deeper into our very own crystal ball, we see that cruel nature will soften her ways, provide us with green grass where there had been brown mud and sand, that the grass will receive a peach tree as fragile as spun glass, alive at least if not fruitful, and on a ledge will flourish the vegetables and forty chickens in splendid health behind wire.

A couple of details should be noted before getting on with the building of the house. They are not overly significant but cautionary, the kind of warning that only crazy artists who think they can command a house to rise would need. Because no other sort of person would rule out the services of a professional architect, no one else would have the *culot* (the nerve) to say, "Architect? I am the architect." Headlong, she rushes into pandemonium. Overweening, she draws plans that float overhead like soap bubbles and have to be explained at length. And as must happen in such an enterprise, she leans more and more humbly on the contractor who, given the circumstance, is soon their chum. It may be said that no big-city entrepreneur, no dashing urban corporation head, no clutch of high-floor brokers, no wily lawyer is foxier in business know-how than the village builder. Ruddy cheeks testify to the great big out-of-doors, the bright grin is twinkly enough for a Santa Claus persona. He wears the latest digital watch; his blue bomber jacket matches his eyes and his Porsche.

He tells stories in his picturesque accent. He waits at the door, motor purring, and drives us up to the *chantier*. He is deferential with M'sieur Max, gallant with Madame. And at Christmas he brings a gift or two: an umbrella, a billfold, calendars, ashtrays. No wonder that with all his charm, all that *bonhomie*, we are soon on first-name terms.

He has invited us for dinner. In his home which he calls his masterpiece, we cast about for a topic and come up with *la fête*. Just three weeks away, the annual four-day bash, stoically awaited during the other three hundred and sixty-one days of the year by Seillan's young, old and middle-aged.

Always the same, *la fête*, an arabesque embedded violently in a gloomy year, something to work for, to depend on, something open and noisy with clean, bright noisy shirts moving in a small sea of bouffant blonde *coiffures*. For, brunettes all, nearly every feminine head among them was certain that by changing the color of your hair you change your life and your potential.

Behind old walls and dark doorways grow young girls who will hear the first notes of *le bal* and will float out to meet them, the heavenly rock strains of *Atomique Jazz et Se Boys*. Hours

later, just out beyond the lights and the garlands, they will blissfully contend with eager youths who know a blonde when they see one, and who think they know what to do with her.

Two days after this *fête* (this is July 1968), with its *pastis* flowing like water, its shooting gallery, its garlic, roulette, and bottle-smashing ninepins, the village square is once more quiet save for the click of *boules* in the late afternoon shade. And up on our hill we lay the cornerstone of our house, a mini-ceremony attended by a dozen hung-over workers as well as our own helpers, Olga and Albert. While the champagne spurts they all stand abashed, *bérets* in hand. Then they cry:

"Bravo, M'sieur Max! Bravo, Madame Max!"

Day after day saw me wave, call the dog and climb the hill. If it was my house it had to be watched, like a nest for birds, that no ill could come. A rectangular nest of stone birds sat upon my chest at night, its builder words securely mortared into my sleep. To this day, if I must describe the *portée d'un poutre*, there is only my precious Harrap's (French-English) to help me say beam-span; the *doloire* that sounds so sad was only a shovel that chopped away at sand and *mortier de chaux* (cement). *Limousinage, bétonnage*, yes, and braces, lintels. Shall I always remember their hinges, their mortises, along with the smiles as I brought from my basket the bottle of wine, *le coup de rouge*? Sometimes Max waved from his window, down below.

Up there I am joshing, discussing the work, using those words that I shall never in all my life use again. Knowledge-able perhaps. Freakish, unwomanly, I feel rather than see the house rise, feeding on me. Biweekly lunch parties at the village hotel brought us together: the mason-contractor, the carpenter (nine generations of trade guild), the plumber, shirt-and-tie man of the world from Nice, the electrician, the tile setter. Our reunions were of the very merriest. I am not going to give descriptions of these people or comment upon them, their gestures, their tics, their indigenous words. They were like men of their calling anywhere, neither droll nor solemn, satanic or adorable. It would be untrue, however, to maintain that lunching with all of them at one table in the village restau-

rant was anything but an ordeal. (Max, of course, stayed safely at home where I, too, might and should have remained had I not held tight to the conviction that the gods of our future hearth, gathered together at the Restaurant Clariond in concord and community of interest, would, without my presence and after a few glasses of Gigondas, forget their high purpose and fall into discord, perhaps even fisticuffs.)

They began by seriously unfolding their big napkins to protect the ties they had put on for the occasion. Orders were for all five courses—they all had lusty appetites and ate their heads off. If I tried to keep up with them, as I did the first time, by swilling the heavy wine and swallowing the *suprême de langouste, perdreau truffé, pissaladière, salade, baba* . . . there was certain to be a day in bed immediately following.

Instead, for two hours I would shamelessly carry on, with winks and laughter, a kind of jollity with these men; banter that I can only describe as grisly and that left me drained and gasping. Tottering home afterward, coming into the sweetly silent house—except for the faraway third-floor sounds of Max in his studio—was, I thought, the way a call girl must feel after her strenuous champagne gaiety when she has thus earned the right to droop and sleep.

It was a period of motley geometries overlaid by diagrams in very straight lines that strain out any taint of fun, providing instead a thousand needles of frustration. First, a two-sided medal marked the working days from those when the crew(s) didn't show up. More subtle were the calculations in numbers. Let's see, tomorrow a team of plumbers will begin to lay the underground pipe. Sure?

Puffing up the hill the next day and feeling exactly like one of those diminutive figures limned by talented monks in their decoration of parchment manuscripts, I found a plumber, a taciturn fellow seated on the ground, idly fitting an elbow into a two-inch plastic pipe (it didn't fit). *"Bonjour."* *" 'Jour."* "Where are all the others?" I asked. He grunted, *"Il n'y a pas d'autres."* ("There aren't any others.")

Tangents to the isosceles are the slanting rains, R, that made work impossible, delays in the arrival from Mars of indispens-

able parts, P, dotted-lined with long intervals of nothingness leading to X, that collapse of a xenolithic stone-pile intended for drainage, occasioning a crushing back injury to our foreman, and diagonally back to Z, the zealous masons who managed to camouflage the lovely stones with gray cement, and Y, your favorite contractor madly misreading your careful dimensions of the pool and digging instead a perhaps secretly desired, municipal, gym-sized water hole. His answer when confronted, "*Je m'excuse.*" Yet everything moved toward dazzling completion; stones came together, oriels framed landscapes and the house cast a marble shadow.

Insanely euphoric by this time, I caused stone carvers to travel from Touraine, trucking the columns they had made to grace the loggia, Maxfield Parrish Doric, between which we would see in the stunning late-day light of rose and ineffable blue, the coral roofs of Seillans.

It was rumored around that such a house could only be dreamed up and built with posterity in mind, that it was surely destined to be a museum when we were gone. I believe this kind of museum or foundation (lovely umbrella word), devoted to the work of one artist, occupies in most minds a place something like that reserved for Jack's beanstalk. It is *there*. Born like the rainbow out of natural phenomena complete with unnatural pot of gold, its doors are open to all. Ten francs. Come in. Beauty reigns. Floors are scrubbed, windows sparkle, there is no dust on the sculpture, the pictures are straight and perfectly lit, the guardian smiles, there are no nimble thieves, no leaks in the roof, no fire would dare, no weeds in the drive, the lawn is mowed (at night, by brownies), there are no bugs in the trees, no rust anywhere. And no mutiny. With such a picture firmly in mind several twentieth-century artists have thus got themselves consecrated. Believing in the reality of their beanstalks, a few have used their own sudden money to build megalostructures into the facades of which they caused patient stone carvers to chisel their names, as on tombstones, or in lights on theater marquees. As for filling up the place, *oh là-là*, a bumper crop of masterpieces waits in the studio.

Up in the Saint-Roc hills, our *quartier*, almost inaccessible

by any but sinewy-calved mountaineers, jeeps and landrovers, we were clearly not preparing for posterity. In fact Max hardly noticed the activity except to drag visitors up there to see the havoc, something that Dorothea was doing with the money people were bringing him. She sometimes asked what he wanted; dimensions of a room, for example, were decided as breezily as choices from a menu. He would in any case opt for the bigger one. This bounty was then something he could give her to play with, for she was in truth playing a game, conjuring out of stone and wood and glass a castle as magical as the one on Jack's beanstalk. Whence the confusion of motives.

On June 17, 1970, moving men struggled up the hill on foot between old house and new, their loaded truck having balked before the steep grade. Two weeks later the transfer—surely it would be the last (it was)—was complete.

Five years were lived in this massive haven—I almost said heaven—where nothing seemed to stem the flow of work and frolic, not even the harassment of the IRS (French equivalent), in the person of a tight-lipped fellow whose suggestion, when Max confessed his ignorance of accounts, "You can keep books in the morning and paint in the afternoon," came too late.

Omens, coincidences, funny, freakish happenings, all cleaving a rather sinister zigzag behind him like the path of a tornado, dogged his step from one opening to another; for they were curious tricks played around his pictures, and brought him up each time, laughing and yet not laughing. They were always good for an amusing story, like those tales of headless ghosts on wild stormy nights that make one shiver while sipping cognac before the roaring grate in the TV-style trophy room of the old castle that your host, its sole heir, has idly decided to visit. Tales within tales.

The first exhibition of his paintings in New York *chez* the intrepid Julien Levy. A good thing the artist was far away in Paris. For it opened in 1932 during a nasty stock market dip. In Los Angeles years later another opening had hardly got under way when it began to snow. Amazing! All present rushed out in the street for the miraculous, never-before-seen snowflakes. How could mere pictures compete? In Brühl (near Co-

logne), his birthplace, a retrospective exhibition was mounted despite the reserve of the city fathers, who smelled anarchy and sedition, and who cried I told you so when a stroke of lightning rent the banner MAX ERNST, strung across the main street, on the very noon of the *vernissage*. Prospective visitors to the exhibition hurried away to church.

Next there was the Hawaiian adventure. By now I am there too. There is an exhibition (both of us, so help me) that contains a number of smoldering little paintings of volcanos (his) made over the past year. In the middle of the reception the news pours in: Kilauea, the big volcano on the island of Hawaii, has just entered into eruption after long years of playing possum. Who cares about painted volcanos?

One day in Paris we prepared to leave next morning for Stuttgart for a Max Ernst retrospective. This terrible date was January 24, 1970. About one in the morning, smelling smoke, Max found our kitchen in flames. "Dorot*a*ya!" he yelled. I stumbled out of sleep and through the flannel smoke to the phone. "I'll call the firemen!"

"No, you will not. They ruin everything," he said. With buckets of water he got the fire down, then said, "Now you can call them." I must say here that they were on hand in four minutes. Visibly disappointed, however, at finding no pretext for the flooding treatment they soon went away, rather grumpily, deprived of water play, only carrying out the charred, smoking cabinets.

Next morning, from up in his studio Max called down to me, "Dorot*a*ya! I want to show you something."

Now what. . . . I went up trembling. Some awful damage surely. . . .

He pointed. There on the easel sat the picture he had made the day before. On a snowy white ground that could have been Finland or Siberia was a rectangular collage, made from magazine ads, slightly angled as was his way, and printed on it just three big letters: FEU (Fire).

We made it to Stuttgart. The show was hung, all was ready. While I rested in the hotel he talked to his hosts at the museum. Then something very strange took place. From my bed

I heard—was it the grinding rumble of a passing truck?—
while at the same time everything churned, the armoire fell
against a bedside table. . . . I lurched to the window. Down
below in the park a few people were running in zigzags. It was
all over in a flash. What had happened? Had the hotel given
way? When Max came in I learned: He had been telling about
the fire at home, laughing as usual. The museum people
laughed too. "All we need now is an earthquake," quipped
someone. It was true. And so they had their earthquake.

Though invariably appealing to women and some men, Max
did not arouse the same affection in the New York art commu-
nity as a whole. In fact, approbation was never quite his. (To
this day he is remembered nervously if not with alarm by a
group into which he never seemed to fit.) Odd attitudes, un-
predictability and the utter absence of *bon ton*, to say nothing
of his not even *noticing*, most damning of all, assured final re-
jection with the same severity that apartment shareholders
wield in passing on would-be occupants of their building.

There was about him something I came to recognize as time
went on, and with trepidation. So now to speak of it at all I
must dig deep for words that, as they surface, turn brown and
dry as clods, leaving me agonized, embarrassed, inadequate.
The presence of this profound and absolutely impenetrable
something—was he carrying some special burden of knowl-
edge beyond the things in books, a heavy arcanum?—removed
him ever so slightly from where he stood, so that his gentle-
ness, his elegance and the whole amalgam of his being spoke of
apartness. Apart from the studio, apart from his books, from
people; from even me, for I saw it clearly and did not panic:
why should I want to plumb his very depths? Why bore be-
hind the cool, faraway gaze directed straight through my eyes,
for at times his regard was of such distance that I was unsettled
and had to swallow a rising knot in my throat. (If there were a
sphinx today what would it look like?)
 Yet, the riddle of his strangeness is the real *raison d'être* for
these pages, no matter what else they may have to say. What-
ever one pictures him doing or not doing, saying or not saying,

it is well to remember that deep-diving absence, hinting at a place I could never hope to fathom. It sat upon him always, not unkindly or yet sad. Save for those funny stories, he seemed not to want to remember anything.

The great bulging bag of his past slumped unopened. Its charms and hideousnesses, so easy for others to drag out and examine, and so hard for him to notice, moldered dankly in their dark nowhere, lost, unfound, and unclaimed.

Does tandem rhyme with problem? We were two, artists as it happened, pursuing careers, so it is assumed. This last, wrong. My own adventure—it might be called typical in this genre—was full of contradiction. Any weighing that had to be done contended with jiggling scales heaped with all kinds of desiderata on both trays. Choosing was not, therefore, the word for what we did. It is a word for the shopper, for sweaters, dishes, details.

If I had weighed my love, laid it like a pulsing heart-shaped lump on the brass scales, with Advancement (star-shaped) on the other tray, I would have been simply contemptible. An artist? Indeed what artist could be anything but mediocre even if, having done the weighing, she decided to risk all for love. What is she risking? All those rousing, honorific speeches, magazine-TV interviews and power precepts were absurdly wide of the mark, in my case. I couldn't find myself anywhere. It seemed clear to me that I had better stay in my corner where making art was allowed. And where I could be one in a two-part rescue operation, reciprocal. There was no consideration of options, no turning over of pros and cons. They say that we are made of water. So maybe I was a river crashing to the sea and merging with another stream on the way, just naturally. How could I flow backwards or sideways? Does the sharing of a direction deprive a female of her imagination? Or her hands? Is it a hardship, is it *unfair* to have to live in an enchanted space where striving after approbation by other not always distinguished human beings is no more than a faraway rumor, frivolous as tipping tables?

To have been in a way a helpmate to so splendid and myste-

rious a human being, while not a privilege (who wants to be a helper, merely?), was in no way painful or degrading. Instead, a strong emotion resembling sympathy would grip me at certain times when he seemed to invite, even *want* me to "take over," at least to share his quiet disarray. But to share the fundamental wild truth that wrapped him close, ah, that was not for me. Why should it be? He could not share mine.

So here in the beginning, there was a single desire growing in me like a weed or a rose, take your pick, to give this little present, a surprise, of telling about Max Ernst, his ways with me and with some others, as well as with himself, and thus to make him accessible for all those who found him abstruse, closed, arrogant, difficult, overweening. For this it is not enough to hold him at arm's length, squinting with my head on one side. He has been too great a part of me and there is no perspective possible. There was time in it, real countdown time, so long a time and so close that the he was mostly a we.

Needless to say, these remarks, or rather gropings, apply to us only as a pair. What came from the outside was, in contrast, a long drawn-out assault as evil as plague with all of its glistening basilisks disguised with names like Friendship, Admiration, Understanding, and one or two, quite headless, called Love. *Fadaises* and platitudes imperfectly covered intentions. They dripped like treacle under the wisteria bower in Touraine or, later, buzzed in the heat with the flies on the Provençal verandah. Moving in on us, each one demanding some kind of attention, flatfooted hints about money, women, the art derby.

THE WINNER IS THE PLAYER WITH THE MOST MONEY AT THE END OF THE GAME. (Toy instruction sheet.)

At some point on one of those sunny afternoons I write myself a message: Money. Make a clean breast of this dismal phenomenon.

How I wish I could! The whole thing makes me dizzy, a perpetual nightmare. I would be no more capable of giving it dignified comment than of getting along without it. If I could meet it, find it sitting snugly in a chair with a face to look at, a

voice to reply to my questions, my accusations, or if I could nab it in an alley, tear the nylon stocking off its head, find out why it has been fiendishly pushing us around forever. . . . It can imitate desire so perfectly that I WANT is your second skin. It can render I NEED positively beguiling. Not to forget the clever reverse side, the underbelly you might say, best worn by your foxy lawyer, that says YOU NEED ME. I need, we need, loomed at times, cruelly tipped the light to dark and brought imbalance to the glad two-in-one house we lived in.

As for Max Ernst, though only an artist, he could be credited with a sizeable real-estate boom. Seeing him, laughing with him, admiring him and carrying off his works seemed to provoke in his visitors an imperious desire to live higher on the hog, starting of course with a new-old *château*, an apartment, a country house, a new art gallery, or several of these, always larger and grander than what they had before.

They fastened upon him as silkworms fasten upon mulberry leaves. There were all kinds of projects: a film festival needed a trophy-sculpture. A town needed a fountain. A crackerjack inventor of multiples needed a painting.

Perhaps the most outlandish were the two excited *messieurs* who wanted to make beds. Live wires, full of zeal, full of babble, full of ideas. Bouvard and Pécuchet. Or Laurel and Hardy. They came down from Paris with a cardboard box that one of them (Bouvard?) carried held out in front of him, a light but precious burden. Blown glass? A rare butterfly?

We all stood around our big table while it was unwrapped to reveal a shaky little bed, doll-house size, head and foot made of two sides of a Japanese birdcage, the kind Max used for his object-paintings. In fact, the picture, *Question insecte*, that these two inventors hoped to "interpret" was at that very moment in his studio.

A bed for surrealist dreams, they said. It would have a moon and a giant spray of (plastic) fern leaves. It would have a coverlet of mink fur. Gimmicks were rampant—wispy end tables, lamps, veneers of the sort found in mail-order catalogs. All they wanted was his permission. Yes, yes. He would receive two beds for his signature! Yes, of course, yes.

This hideous object was actually realized in a number of copies, cardboard moon, plastic leaves, pitiful minks and all. *Les messieurs* could barely contain their excitement. "Where will you put yours?" one of them asked me in gushing effusion.

Our cellar folded its cobwebs over the thing upon its delivery. And after a flurry of embarrassing, pulpy publicity, the whole project fell apart. There were beds in Swiss warehouses, a bed in a Munich emporium, beds in the factory. We had only to palm off ours to forget the whole miserable fiasco.

Generous to the point of detachment, he gave. That never came to an end. Hardly a day passed after we left the safe haven of Arizona that did not see at least one drawing flutter from under his hand to perch in some acquaintance-tree. Rare portfolios, albums, *frottages*, etchings were passed out like cookies if there were any on the table. He never knew what happened with his sculptures. Always someone to tell him: "Money is being put away for you," like a child.

Why didn't I do something? Would I, could I be one of *those wives*? Would I ever be one of those widows? *Les veuves abusives* were his mocking words for them.

How can one piece together a cohesive history when so much connective material is hidden away in private caches on several continents? The answer is that one cannot. This may have been his intention.

His wife, also an artist, that's me, can be credited with having stimulated sales in Paris flea markets, perfumeries, stores and boutiques of moderately priced jewelry. For the friends invariably brought some trinket as you would fling a bone to the dog to keep it from barking. Sometimes Max opened his eyes wide, saw through the flimsy ploy, and rebelled. Or sometimes there just wasn't anymore. Sculpture? Collages? *Frottages*? Then, in proportion to the shrinking of the booty, the bottles of perfume shrank too until the day when, the big deals having come to an end, there wasn't any more perfume at all.

It was amusing, when a gesture was in order, to offer a piece of her own making and to register the little squint of mirrored

deception upon receiving one of hers instead of one of his. Politeness demanding, everyone smiled.

Thus I have spoken of my place in this world of visits. But what I have not said, and must, is about my place as an artist. Ah, there the delicate rapiers of almost constant thrust—curiously unintentional in the main and, as such, all the more offensive—demanded of me all the force of my patience and my pride to brush them off.

What had happened to my petulance? How had my lifelong lordliness wound up in a tangle of maneuvers having to do with woman rather than artist? From one moment to the next—the time it takes to fall hopelessly in love or face a firing squad—I was transferred from my unapproachable aerie to a nest on the ground. Solitary, I had set my jaw a thousand times, had curled my lip, had been sly, had been steady. Invincible? The world would answer that, would put things straight, would bring down all high flyers of the wrong gender.

It began with little drifts of time out for the unexpected; compromise seeped in unnoticed, mere waftures really, hardly to be confused with capitulation. Over and over. No matter, I was tempered steel. And yet again, just in a moment when we said, "Now it is as it should be," for we were after all two to brave the many. I dwelt more and more in sublimation-land while the assault from without mounted in numbers and ferocity. He, my Max, stood helplessly by, incredulous and miserable. Sometimes he ignored the museum directors' requests just because of their rudeness to me. As if it helped! They bearded him, they positively lunged against our crystal, but could not bruise even one facet.

Two studios holding two artists; two easels, his and hers; the same clutter of tables, the sounds are similar. Are we what? A school, a laboratory, a cottage industry? And the tardy thought: would it have been, perhaps, better, two *métiers* instead of one? And better for whom? For that we would have had to take two different mates. No awkward hammering in unison, no identical turpentine clouds drifting from two doors, no mournful confusion of wall space in visiting minds.

From the very start, "they" were ready, eager and deter-

mined to spot his *influence*. Never underestimate this word. It is everywhere, favorite nib of the poverty-stricken pen. Once, looking over a two-page article about my work, I counted the names of twenty-three artists. It was fun breaking this list down into centuries and finding that I was rather equally indebted to the nineteenth and the twentieth, to Italian, French, British, and Japanese (masters, of course), and that my work was, to say the least, feminine. Another time the art critic of a prestigious New York weekly, reviewing a mixed bag of paintings on view somewhere saw fit to describe my *Birthday* as "hard, harsh and shallow, but effective."

Indeed, effective it must have been, for reappearing in another show the following year it was mentioned by the same critic as being painted by a "talented newcomer." Was he losing his grip? Because when it was borrowed seven years later for one of those sweeping surveys called blockbusters that museums like to mount, the whole fabric of his intransigence had by that time apparently disintegrated, and the critic, reeling from his capitulation, called *Birthday* one of the "highlights" of the show. It was upon reading this last spasm of copy that the subject of art criticism gave me some moments of bemused reflection as well as a strong conviction that familiarity, far from breeding contempt, bringeth on pleasure and understanding.

One moist Paris evening, in a mood of melancholy reflexion, I sat in a concert at the Maison de la Radio listening to a composer (K. Stockhausen) conduct his piece, "Hymnen," a music that jolted me out of my negative thoughts and incredibly but clearly showed me what I had to do. Spinning among the unearthly sounds of "Hymnen" were the earthy even organic shapes that I would make, had to make, out of cloth and wool; I saw them so clearly, living materials becoming living sculptures, their life-span something like ours. Fugacious they would be, and fragile, to please me, their creator and survivor. I was suddenly content and powerful as I looked around. No one knew what was going on inside me. I had forgotten about "Hymnen," only noticing when it ended and everyone stood up, and I felt potent and seminal the way one does about works that have not yet happened.

This, then, was the genesis of what became five years of sculpture activity. Carried on in my studio in Seillans, the work did not involve familiar canvas or paint but carded wool and endless lengths of sensuous tweeds, the chopping up of which provided thrills of a kind very close to peril.

Sometimes I remembered that musical evening where a risk had been taken and tamed. And where my melancholy had dissolved before the fact. An artist is the sum of his risks, I thought, the life and death kind. So, in league with my sewing machine, I pulled and stitched and stuffed the banal materials of human clothing in a transformation process where the most astonished witness was myself.

Max did not welcome unannounced irruptions into the studio. Nor for that matter did I. Visits were by invitation.

At home, at peace, just us, a new picture was the occasion for: "Would you care to see. . . ?" Oh yes! You came, you gazed, you spoke your mind. If I said words like beautiful, luminous, magical, new, serene, challenging, vigorous, final, it was because I meant them. Once in a while a wrong note would rile the air: "That little yellow area," I might venture, "couldn't it be better green? I just wonder about that yellow bit . . . " A bad moment. "You!" The brash critic is dismissed. Sad, sad evening. But the next day there is a visitor and I trail behind into Max's studio where I see the yellow bit has changed to green. I am absurdly happy. In truth he would do almost anything for me, I think blissfully.

The same invitation, the same visit in reverse. My studio, my new picture. He comes, he gazes, he says, "Wonderful." "Do you really like it?" "It's wonderful." "But isn't there something? That form in the blue rectangle there, tell me, really . . . " "But I *told* you—it's wonderful." "But . . . you can say *something*. I won't be mad." And he, losing patience now: "*Ecoute*. I said it was wonderful. What do you want? What can I say more?" walking out in a huff. The next day at lunch I make a little announcement: "Max, that picture I showed you yesterday . . . the new one with the blue *fond* . . . " "Yes?" "Well, I destroyed it." He throws down his napkin, he

glares, he thunders "NO!" And after a moment: "Well, it wasn't your best."

At times I felt a flush of resentment. A candid opinion, even a sketch of real judgment, perfectly severe, even brutal, was what I thought I wanted. Of course he was right. The master's verdict would have been as odious to him as, later, to me. An insult, an assassination. You have your own eye, your own heart, your own soul. What need of the teacher's foot in the bounteous garden of all that plenty?

"What is this mania for learning?" he would say. "Teachers! Everyone seems to be a teacher or a learner. What can you learn that isn't in eyes and books?" "You can teach how to see," I said. "You can't teach how to do," said he. And I, "You can teach how to think. . . ."

"Not how to feel." He thus had the last word.

He might have been thinking about our teaching stint (teaching!) in Honolulu (remember that volcano?) and the thirty lectures he gave at the university in that summer of 1952, delivered to a super-ethnic, packed auditorium. When the time came to grade students he rebelled; it could not be contemplated. The role of judge was repugnant; oh no, it had nothing to do with him. So the deed was quietly done by Wes, his treasured assistant.

Affable and smiling, he would open doors wide, ever eager for the good surprise. If confronted with silliness or misunder-standing, he merely turned away, as he had done back in Se-dona with the unsurprising laundry parcel, his consummate disdain written in the ceiling-ward gaze. Or humor would take over as he poured puns, laced with his own brand of funni-ness, and champagne for all.

Did he ever give a thought to prudence? Was tact a word for the toolshed or a new kind of toothpaste? Fired by nothing more dangerous than candor, he swept through sham and ear-nestness alike, cutting down with a pair of scissor-words the airy web of fake or mandarin. Right or wrong, this was Max to the bone. Time and events had borne him out in his rejection of the powerful, ample proof having been furnished that one could live quite fully without them, uninvolved in charting

positions of a hierarchical kind. With his grin to dress up the devastating remark and his spontaneous participation in our frequent foolish goings-on, high jinks of a quite juvenile purity of impulse—all revealed for him an unself-consciousness I would have given worlds to claim.

Sometimes I slightly wished he wasn't so right, hadn't done it so serenely. I would have liked to see a big crack so that I could jump in to help. To make of our twain the ultimate symmetry. "Indispensable Dorothea. She dolled up his life." Fragile dream. For I was not that necessary; anyone could see that he had always done it, always would do it, with or without an eager D. T. All of which had nothing to do with his very satisfying passion for me.

Well-defined loyalties were as alien to him as well-defined conventions. Open allegiance to any group, nation, party— even the surrealist movement had its hands full, with his often anarchic tangents, resulting in repeated exclusion and equally repeated blandishments—while not actually distasteful to him, was somehow awkward. The warm feathered nests of family feeling and bloodlines were viewed as traps; one flew over them, one did not alight. Blood, though indispensable, was as morose inside as when it ran out on the ground. Causes, parties and flags ("the flag should be hoisted briskly and lowered ceremoniously") were merely wearisome. He was sure to turn his gaze to the ceiling whenever some *engagé* embarked on a political harangue. Leaning forward on strongly planted feet, always careful of his big, ropy, precious, secretive hands, he was absently unconcerned with prevalent rituals. He did not hold doors open for ladies or take one's arm to cross the street.

Dignitaries and celebrities were make-believe. Theater was on pages, not stages. He read avidly in Strindberg—too avidly, I thought—and Shakespeare, "Of course he wrote to be read." He went to the movies as all artists do: for pictures. Matta, another artist-addict of films, once said to me that there is no movie, no matter how abject, that will not give you one splendid moment.

*

148

Time blurs, and I now rarely blurt out Max mirrors: Max said . . . Max preferred . . . Max disdained . . . Max would always . . . Max never failed to . . . Max once told me . . . Max

His do's and dont's were often vehement and always colorful. The do's are all over this book. Here are some of the dont's:

Don't regret horses. Just be thankful their martyrdom is over.

Don't eat health food. Don't put flour in the sauce. Don't say you love a shoe.

Don't take too long to buy something. Your time is worth more than your money.

Never wake anyone out of a sound sleep. (How he enjoyed telling of the court trial: a man who murdered his wife for waking him—and was acquitted!)

Don't ever confess anything.

This last he scrupulously observed during our entire thirty-four years. Nor did he ever utter the words, "I'm sorry," or "it was my fault."

To the above dont's I must add one of my own:

Never be persuaded to eat, drink, smoke, or insert anything you don't want.

IX *Folding Wings*

1975. Loplop has plummeted, left wing forever still. The year is tense, eleven losing months on the number-clogged calendar. His bed is the axis; around it everything turns. The high white bed that narrowly holds his disgust, the deception lying in his eyes. On the next to the last day he asks his visitor, his old friend Robert:

"Tell me, Robert, what do you think of the letter!"

"The letter?"

Max insists: "Oh yes, you know what I mean. . . . "

Robert treads warily: "But. . . . "

And Max, "The letter, the letter. Rimbaud's letter. *La lettre du voyant.*"

This enigmatic letter that Rimbaud wrote to his friend and confidant, Georges Izambard, has never to this day been satisfactorily explained. As his final hours sift down, Max Ernst reveals his pondering. Of all that he has seen, of all the spheres he has negotiated, the towers he has thrown up, the prisons he has escaped; of all that he has loved or honored or questioned, of all the words he has read in all his long life it is Rimbaud's letter that holds him now. There it is, locked in the darkening corridors of his mind, its riddle intact.

He has not the slightest wish to know what, clinically, has happened to him. The presence of the pretty nurses is merely necessary; they do their work as he watches, already quiet, his care and feeding with silent and sovereign detachment. His indifference to medicine is total. The breathless doctor surges in *every day*, watches, doses, juggles the drugs.

People come and go. Friend Patrick says, "Don't despair, Dorothea. Georges B. lived for eight years in his bed" (paralyzed of course). Is this supposed to give me hope? Shall I be grateful for a horizontal Max, a fragile doll in the high bed? Would Max be relieved knowing he could hang on by such a

thread? Would we both learn during those endless days, watching the tiny dawns grow to ferocious noons and then slowly, slowly to dark and perhaps sleep, so that we might begin again next morning to make a bigger effort at learning hard to like the bubble; would we learn, he on the inside, me on the outside, unable even to hold hands, "Don't you touch that!" The still hand.

"Let us think of him now without being disorderly." Leaning to me someone said it, and we as soon saw that it was not possible. Almost a whole year in that bed, knowing. He watched TV. Watched tumbling horses, the explosions. Watched the insects, gloriously enlarged and translucent, their intent, jerky movements so purposeful; no wonder they are stronger than we. Watching the cowboy's lined face he might have thought of twangy Sedona, far away now; watching Bugs Bunny, international deity, with that laughing voice, not human, not rabbit, soon stifled on the dirty floor of commercial time, where a zealous mop, having imbibed a detergent, swipes across the filth, revealing a bright rectangular swath that becomes a window in the blur of our woe.

Unshakable, removed. As he lay there it was stunningly clear that he would die. And that there would be no compromise, no revelation, nothing for me anywhere. He would die as a bird dies, wings closed, useless as painted tin, sloughing off those around him, the bossy nurses, the little cook in her tight jeans and loud clogs, the distraught wife, the burlesque doctor, the visitors illustrious or not. All strangers all. Family, country, gods, all waited outside. He had plenty of time dying to capitulate, but did not.

There is the voice of Aragon who sits beside the bed: "Remember, Max?" Reminding, remembering the great days. Max half listens or not at all, his eyes on the television. Woody Woodpecker outwits the Fox. And Aragon, immense, carried away: "Remember, Max, the time when I hustled you out of that fracas at the Dôme, with dozens of cops swarming in? We were all Paris hometown brawlers, the rest of us, nothing to fear; but you, *pauvre bougre*, with your impossible German passport. . . ."

Oh Max, turn your eyes to us. "Max, honey, Aragon

says. . . ." Woody winks, Max watches. "Mmmm," he says faintly.

Showing us the so obvious answer. But then he is sleepy and the answer can wait. Aragon will go, sad because his charming souvenirs must lie quietly in his memory and will not be shared by his old friend.

I cannot help noticing that he does not mention the rally of twelve years before when he had asked us to join him for a "ballet benefit." Of course. Arriving at the Palais d'Hiver we were ushered through dense crowds of *humanité* (Aragon's newspaper: *L'Humanité*), down to the front row where, to my stupefaction, I found myself seated between Waldeck Rochet, French communism's then boss, and my poor Max who, though trapped, bore the half-hour prelude of flash bulbs with tight-lipped fortitude.

At one point in this interminable evening (there is no ballet), Aragon, in his pretty black velvet suit, leaps with crisp energy onto the stage and reads poetry from a sheaf of papers. By this time my brain is so glazed that his voice comes to me as abstract sound and the subsequent wild applause as menace. I look around. The immense space is packed with faces, all with the dreary look of controlled bitterness about pleasures they do not want; angular or round, dark or pale, they will, when commanded, sing lustily, cry hoarsely, trample thoroughly. I felt *surrounded*. It was clear that I had better sit tight. Every few minutes some photographer would snap around front to shoot us, Monsieur Rochet on my right, Max on my left. How should I look? Should I smile? Look stern? Preoccupied? Impossible to hide. I would steal glances at shaggy Monsieur Rochet. He was intense, tousled, his eyes were parked under shady trees. Needless to say, no words were exchanged between us. He probably thought of my chair as being unoccupied.

Although this was not the worst thing that ever happened to me, it was certainly one of the most grotesque. It had the same quasi-comical scenario as those dreams in which you are, say, naked at the airport, facing a long wait for your clothes on the carousel. Was it really me, Dotty Tanning from Galesburg, the tender romantic, her fabric shot through with dreams of

unearthly splendor, metamorphosis, sorcery, enchantment? Yes, sit tight.

When it was over we pushed out unnoticed, while Aragon basked, surrounded and happy as he is here in this afternoon gloom, an altogether indomitable man. Goodbye, goodbye. . . .

Day pales to evening. TV girls, TV races and barking guns, a variety of sounds, the sounds are the targets. Undulating TV hair to prove something, to prove that everything is undulating, smoke, fire, fields, lava, water, worms, women under men. Now the lamps are lit and he is drugged to sleep. The evening is stony with its dead TV and its mocking teeth of hopeless white death sitting comfortably in the big soft round chair that Max cannot bear. It had been brought in for him, his favorite chair.

Here comes night to turn the room to blotch and sweep away our walls. What is the time? Is it something to laugh off? All the talk about how it doesn't exist. And here it is, taking charge, churning all, chastising bodies, bodies turning inside out, feeling cheap and jerry-built. Resentful bodies, forever dueling with minds. I am here, we are both here, it is midnight. Or is it? Early dawn is seeping in, a kind of blue dust on the dark. My lungs breathe worthless air that nobody wants, least of all Max.

He is as positioned in the firmament of human stars as those other ones upon whom we lean, knowingly or unknowingly, our temerities propped by the monuments left in their wake. I believe he knew this. Like them he did not find it pre-eminent or requiring acknowledgment from himself. A blazing planet does not see its own reflection. Instead, the steady gaze, the ready gift, the luxury, the irony, the distance define him, the happened artist. Happened, I say, for his was a kind of vision that could only burst the seams of painted art.

Trying to bring him into focus, I am stingingly aware of my huge inadequacy. It resembles in a way the clumsy, wrong brushstrokes of picture restorers. I saw from the start that the tag "painter" would not place Max. It puts him with those who *can paint*. They are great painters, they did it well, better, best. Acrobats. But what do you call someone who invites you to step outside the rational world and to contend with the imponderables? Someone who does this without words but with

156

signs, symbols, arcane intimations arranged on surfaces, slyly passing for paintings, where the very absences make their comment, where something you think you recognize, a wheel, a beetle or a blaze has been put there as point, not paint. Unartistic. Serenely disrespectful of the *métier*.

How would it have been here without him? It is not even possible for me to imagine this, the words evaporate, there is no structure and surely nothing now would be as it is.

Tonight, gray is the end color, the end result. Ash is the color of the sky, the lid of the town, the fur in the mouth. Time lives with space, unperturbed; Father Time, Mother Space. They are king and queen of the world and the universe and the whole bit. Invincible. They are the only ones.

There is no sound, his breath is feather-silent. A private event is taking place. Not to be disturbed by sorrowing faces, Loplop, Bird Superior, prepares in solitude, in the graceful space of his lofty aerie, his diminishing and his departure.

He is like a lake with an echo: I say Max, everyone says Max, the lake says Max, the echo says Max (far away), and Max is everywhere and part of my throat and the mote in the air.

I hold my screaming ears that no one but me can hear.

Now a frown is stamped upon
This would-be perfect day.
Who pussyfoots the morning hours?
Who sleeps instead of me?

April 1976. There is no light in the studio, nothing moves and
the colored jokes are fading fast. The disorder is grievous. (Is
the heart condemned to break each day?)

June. Still in the studio. Everything is there at the bottom of
my crazy brain. Everything. But it's stone-heavy and will not
rise. Most of the time it's all dark down there. You can stumble
around for hours without joy. My mind is a cave and its words
are hidden in boxes and trunks with lost or rusty keys. If you
find the keys they don't fit the locks. Or if they fit they don't
turn. Or if they open the lock the lid does not rise, the hinges
are stiff. Even if, finally, the trunk is opened, most of its con-
tents are rotted or moldy from their long wait and aren't worth
the trouble of dragging into the light.

A summer and then another took me and my valise away from
there. To Seillans, which sent me back foggier each time. Not
at all sure about what now, I am hardly more than a diagram of
anatomy, the stringy crimson-blue of nerves *sans* epiderm.
Dove gray Paris, most ineffable of cities is still home base,
where there are friends for advice: *Il faut refaire ta vie*, mean-
ing *with* someone. Provoking an inward shudder.

Spring 1979.
 A procession of pale afternoons sees me behind the graying
curtains of our white rooms. No. I must learn to say my. My
rooms. In the rue de Lille. White all around, of walls and
floors turning brownward gray, so mimetic to my mood.

Downy goose gray, gentler than all that white. Now the real city is inside, a sift of black that I accept, all defenses down.

So my rooms, in which I am polite to all. In which I am instructed as to my situation: not bad, really, if you know your place, do as you're told, do not ask questions, and remember that you are, well, a woman, a widow, and not very reliable.

What am I doing here?

While some few talk of discourse, others of project, I am bubbling down into a swamp of silence far deeper than I would have thought possible. When I say "we" this and that, or "our," I am referring to what? A place, a tribe, a country? Do I identify with the human or do I just happen to be one? Happily they believe, the others who outwardly resemble me, that I am one hundred percent genuine. Lucky me, surrounded by them as I am, that they don't squash me, for it would be so easy. The social structure seems miraculously to keep chaos at bay. Most of the time we, they, don't harm each other. And if disciples sharpen their pink wits on the wrong people all the better—I can more easily *passer inaperçue*.

A year later and I have returned to New York as naturally as a pigeon; where I practice conformity, the finest freedom. You sit on chairs or stand in shoes, sometimes with something in your hand like a knife or, say, a glass of liquid that you don't spill or throw but precisely bring to your lips from time to time, taking small sips. You are presenting a pleasant facial expression—this of course when you are with them and, funnily enough, even sometimes when you are alone, taking the small sips exactly in the same way and standing, but without the tight shoes, although this too is not sure for the shoes are sometimes left on the feet, quite conveniently satisfying the need for small pain.

Ah yes, if I obey the laws, written and unwritten, official, stately, natural, or tribal, then I will not be harmed, my body will remain intact, will not be dismembered like the bodies of foolish grasshoppers who grew bold and let themselves be caught only to lose a big green leg and then how would I leap from place to place?

*

If now at this late moment and pulling into the stretch I take on the wiliest, trickiest, most daunting subject—the painting of a picture—the first question is: why?

A big mushroom cloud interposes its load of smog and no one wants to name the thing, the close-boned fundamental experience. It is big. An upheaval. It demands stamina; it involves a wrenching, exalted, pulverizing process that you could call making something out of nothing. Your heart beats fast—after all you could fail—you give everything you think you have—above all nothing from the outside. It is a solitary business.

The beginning is uneasy. Only witness: the studio where an event is about to take place. Not proud, not humble, not at all certain of anything nor yet uncertain, you play with the light, although there is no need, so filled is your inner vision with promise, the kind that shifts behind your eyes in and out of focus.

There is confidence too in what would appear at first to be a gestural rite but soon reveals itself as a contemplation. With questions about the millions of ways it can happen, yes, but withholding the answers you long for. Or do you? Perhaps you already have the answer you want to give. Because pride is there too. How sure you are! How calm, even heedless!

To stand back and see what has been done, to know it is and will be unique, everyone wants it deep down, wants it more than anything. Not everyone will say so. Instead, on a studio visit, you are likely to be treated to a kind of professional modesty on the part of the artist who far from jumping up and down and beating himself on the chest is silent and studious, something like a researcher in a science lab, complete with serious glasses on a chain, sneakers, spotty coveralls, mysterious beakers emanating formulae, stylish clichés ready for the TV.

One thing is certain: no one else could bring it off—your picture. How could they? The very smallest touch, the smudge called up from your own cache of smudges, the bold swath you will dare to trace across a rectangular surface, these are yours. They invite, they menace, they defy while you pause. You are a crowded closet piled with chaos, yet you know that just behind the door is an arrow pointing to the one

splendid sweet line you think you need, the stroke that will take over and multiply until the it having become a they, you have found a way out. Grasp it. It is your fingerprint, your whorled map. All unnoticed then comes choice because, and here is where the unpredictable begins, you will choose. Not all at once, not one choice. But at every moment, every move, every thought and every fraction of thought, facet-flashing, swifter than swift. Such banquets of signs seen, never before seen, authentic all the same.

And the perils! Your hand may falter, misunderstand. A grubby stain, a wrong swath and the humiliation of bowing, bending, taking it out. Or, having left it in, a looking away, and the certainty that all is lost, irrevocably. No, stop! This cannot happen.

Thus she came one morning to the studio. The floor was littered with the debris of last week and the day before. Tables held fast under their load of tubes and brushes, cans and bottles interspersed with hair roller pins, a view of Delft, a stapler, a plastic tub of gypsum powder, a Polaroid of two dogs, green flashbulbs for eyes, a postcard picturing the retreating backs of six nudists on a eucalyptus-shaded path, a nibless pen, an episcope. On the floor or on the wall or on the easel, a new surface waits whitely.

Sensors have drifted like snow, piled up against the door. I am in a glass-bottomed boat looking out at the avenue. I have been there forever. Vogues in art have come and gone. They have provided isms for every taste and every media. Eyes no longer widen. We look at *les Fauves* and wonder why the name. Such earnest, good work. . . . It was dada that rocked the boat, spawned surrealism while standing on its head.

For a while fervent works bore no titles, only numbers. *Number 18*. But *Number 18*, why, that is a very descriptive title! It means this is the eighteenth picture I've painted this year, like *This Dog Has Just Saved This Little Girl From Drowning*. One is immediately curious about something so referential. What about all the other seventeen pictures? Are they like Number 18? It would be better, perhaps, to be looking at Number 12, say. (Number 18 is *just* Number 18.) Anyway, it shows the world this artist is productive. He doesn't sit around; he paints. Eighteen works already and it's only March

15. Black pictures, blue pictures, apricot pictures. Sometimes I saw them in books as you would look out at a street incident, respectful but detached. Better to stay inside with my own dramas. Better to paint my own fantasms, build my own creatures, live my own lies. There is no use hassling with window-pane dreams.

Battle green, blood geranium, rubbed bloody black, drop of old rain. The canvas lies under your liquid hand. Explosia, a new planet invented with its name. "That's what we paint for, invention. Unheard-of news, flowers, or flesh," I've said it again and again. "Not a procedure," I say to the room. "Nothing to do with twenty-four hours: just an admixture for all five senses, the sixth one to be dealt with separately."

Because this is only the beginning. A long flashed life, as they say, before dying.

For thirty-five years life was love, a second skin. Authoritative, instinctual love. Now life is life; sybaritic, an absolutely polished structure of skeletal simplicity. Uninvolved, uncommitted, underworn, deeply and evenly breathed. Its second plot, not life but art, unfolds painty wings each day to try the air, pushing out perhaps reluctant visions of other lives. They too, the visions, uninvolved, yes, unaware of their public category.

It is one of those days and there is still time to reconsider. Time to turn inside out before the first gesture. You have drawn up a stool and sit gazing at the whiteness, feeling suddenly vulnerable and panic-stricken before your lighthearted intention. What has happened, where is the euphoria, the confidence of five minutes ago? Why is certainty receding like distance, eluding you, paling out to leave the whiteness as no more than a pitiless color? Is a canvas defiant, sullen? Something must be done.

Ambivalent feelings, then, for the blank rectangle. On one hand the innocent space, possibilities at your mercy; a conspiracy is shaping up. You and the canvas are in this together. Or are you? For, seen the other way, there is something queerly hostile, a void as full of resistance as the trackless sky, as mocking as heat lightning. If it invites to conspiracy it also coldly challenges to battle.

Quite mechanically during these first moments—moments?

hours?—the little bowl has been filled with things like turpentine and varnish; tubes of color have been chosen, like jewels on a tray, and squeezed, snaky blobs, onto a paper palette. The beautiful colors give heart. Soon they will explode. A shaft of cobalt violet. With echoes from alizarin and titanium and purple—which is really red. There is orange from Mars, Mars Orange. The sound of their names, like planets: Cerulean and Earthshadow, raw or burnt; Ultramarine out of the sea, Barite and Monacal and Vermilion. Siren sounds of cochineal and dragons blood, and gamboge and the lake from blackthorn berries that draw you after them; they sing in your ear, promising that merely to dip a brush in their suavities will produce a miracle.

What does it matter that more often than not the artist is dashed against the rocks and the miracle recedes, a dim phosphorescence? Something has remained: the picture that has taken possession of the cloth, the board, the wall. No longer a blind surface, it is what? You can ask; she too is asking, mute before the evidence. Because it will be an event, it will be a birthday, it will mark a day in a chaotic world and will become order. Calm in its commotion, voluptuous in its space.

Here it is, seduction taking the place of awe. After a quick decision—was it not planned in the middle of the night—a thin brush is chosen, is dipped and dipped again. Madder. Violet. Gold Ocher. A last stare at the grim whiteness before taking the plunge, made at last with the abandon "of divers," said Henry James, speaking of birds, "not expecting to rise again." Now, after only seconds, blankness and nothingness are routed forever.

A hundred forms loom in charming mock dimensions while with each stroke (now there are five brushes in two hands) a thousand other pictures solicit permanence. Somewhere the buzzer buzzes faintly. Sounds from the street drift up, the drone of a plane drifts down. The phone may have rung. A lunchless lunch hour came and went.

The beleaguered canvas is on the floor. Colors are merging. Cobalt and Chrome bridge a gap with their knowing nuances. Where is the Cadmium Red-orange? The tubes are in disorder, their caps lost, their labels smeared with wrong colors.

Oh, where is the red-orange, for it is at this moment the only color in the world and Dionysus the only deity.

Now there is no light at all in the studio. The day is packing up, but who cares? With a voice of its own the canvas hums a tune for the twilight hour, half heard, half seen. Outlines dance; sonic eyes bid you watch out for surprises that break all the rules: white on black making blue; space that deepens with clutter; best of all, the fierce, ambivalent human contour that catches sound and sight and makes of me a slave. Ah, now the world will not be exactly as it was this morning! Mutation has taken place and here in this room leans a picture that is at last in league with its painter, hostilities forgotten. For today.

As brushes are cleaned and windows opened to clear the turpentine air, the artist steals glances—*do not look too long*—at the living, breathing picture, for it is already a picture. She is once again lighthearted, even lightheaded, her mood is vaporous. There are blessed long hours before tomorrow.

An evening may be full of silence or din, it is merely separate. Then a lamplit hour as I prepare for sleep, without braking even one out of all the flashing thoughts that cross my mind as fast as auto racers crossing the finish line, with always another one just behind to take its place. Noisy cutouts of thoughts are reflecting the people cutouts of the evening just over. Outlines of persons who occupied the event, whatever it was, are the revving motors of reflection. They possess me truly; I follow the slashed ribbons of their lives and of their possible lives, of what they did, do and might do—to say nothing of what and who they were, wore, are and will be, may be. What they said.

"Artists are mothers. If you don't admire their works they hate you."

"Are you so sure? . . . Maybe we are all mothers."

"More like evangelists. Only instead of selling God we are selling ourselves. Remember: the idle painter winneth no fame."

"What an attitude! Better deal with that word *avant-garde?* There was such a thing, it came along with the century. They were breaking ground."

"You mean throwing everything."

"Even words. You would not believe their irreverence. The tone was boisterous. They risked plague and taboo but they said it was nothing."

"Ah then you mean dada. Yes. It was called a movement— terrible word. An explosion spurting revolt like lava. A matter of six or seven years. Until the lava turned into cinder blocks."

It was to be expected, I thought, listening. Movements have short lives. They dry and stiffen. But while they last there is no ceiling.

Surrealism, for instance, a crowded word, a not quite spontaneous combustion. No flags wave, no slogans defile its fabric, no cards are carried. No attentive scholars to monitor the madness. (That will come later.) No museums, no art freaks would touch it. No PR—indeed, what could that be?

The only movement smashed by international war, this quivering experiment in psychic discovery could not survive the storm. Minds were slaughtered or maimed along with bodies. Survivors climbed onto the raft outwardly safe, inwardly shattered.

Thus as we have seen some of them got to New York. But it was never the same. And to Breton's disbelief a few stayed on to become Americans while he, staunch captain of his sinking ship, returned to sit daily in the same café, surrounded by the young pedants who had replaced his banished (vanished) fellow souls, wanting until the very end to believe they were as real. Indulgent, he listened. Their staccato pirouettes glanced like pebbles off the rock of his implacable intelligence. He waited, sad, polite.

In August 1949 we too are there with him. An epitome of desuetude, the café is deserted except for the surrealists. There they sit, votaries all, typecast around the table. As Goethe in Weimar, Dante on that Florentine bridge, Freud in his Vienna, a tall blind house. Or there, on the place Blanche with André Breton. Before each one a grail of a sort: Ricard, Cinzano, Noilly Prat, even Coke ("*Saleté chimique*," sneers someone). All iceless.

I spoke little French then. Imagine how I must have appeared, hunched against Max's shoulder for hours in that café where Breton reigned over a dozen excitable windbags strenuously imitating the pronouncements of their chief, my ears positively standing forth, my face arranged in what I hoped was a knowing expression. Then, like faithless groupies we began playing hooky, Max and I, attending less and less often, finally not at all. Until, in 1954 the Venetian sin, the *primo premio* that brought Max's "exclusion" from the surrealist group. He seemed not to notice except for a snort of derision.

A few are still around to wonder aghast at the spectacle of drought that has replaced all that mad, luxuriant, explosive, howling weather that came to mean avant-garde. The vanguard. Adopted now like an orphan, its brash upheavals channeled, its cyclones harnessed. A tag word, appropriated, stripped, meaningless as the label in a shirt.

You squeeze your eyes, close your mind to unavowable feelings. Regret? Pity? Disappointment? Even a kind of frustration can rub off on you in the dark, though it is mostly feeling sorry, so sorry for someone, someones, for lonely anguish seen in public places. In that railway washroom someone bent over a bowl and whispered in another language. At John Cage's concert it happened after the performance was under way. A swinging door broke the hush and a woman sidled elaborately into the theater. Like any minor irritation it was to be ignored. But after several minutes she was still there tiptoeing down the three little steps that led to the seats. She was, one soon realized, elsewhere. And in all her movements she was totally alone. Alone somewhere, hearing the astral sounds called forth by John.

So, each of us there was utterly alone and tumbling in a siren space freed of earthly fundamentals. Only, instead of following on thin, inaudible sound and leaving emotions behind with other flotsam such as gravity and disorder, I found myself rolling on a sea of strong feeling, shamelessly involved with my planet: sorry for every rent in every fabric, for tormentor and tormented, for lost dogs, for *all* dogs. (Cult animal sacrifice: in a Brooklyn garage they wait for their ritual death. The

policeman: "They used to kill babies too.") Elegant broken legs of horses, elephants that die assassinated in the savannah, swarmed by flies. For fish out of water, flopping. Ah, don't look. For bulls made fools of by strutting morons. As much distress suffuses me about a clubbed snake as about a fallen bird, a maimed toad and the seals. Bears in traps, steel jaws biting through their mangled arms. . . . Most terrible of all, our own human pain, compounded as it is by hopeless pride and prideful hope, ingredients in the nepenthean formula, Supremacy: problem drug, widespread, habit-forming, unchecked, planetary poison shared by all but poet and madman, artists both. Outraged and outwitted, they see no way to help.

Have I slept? Once again before the daubed canvas, which is now upright in the harsh morning light. I am aghast.

How could anyone have found it good, even a good start? Traitorous twilight, fostering those balloons of pride that had floated all over the studio! Yesterday had ended in a festival, had been positively buoyant. Syncopating with glances canvasward, brush-cleaning drudgery had been a breeze (what a hellish task after a failed day). Now you are bound. The canvas is to be reckoned with. It breathes, however feebly. It whispers a satanic suggestion for the fast, easy solution, "Others have done it, do it, why not you?" How to explain? There is no fast and easy for me.

Daily depths of depression, as familiar as a limp is to the war-wounded, are followed by momentary exaltations, sometimes quiet certainties: Yeah, that's it. . . . But if that is it, then the presence . . . on . . . the other side . . . all changed now, dark again. . . . Must wait for tomorrow. . . . Oh God . . . how awful. . . .

It is not all joy as they would have us believe. The bearded fellow in his dungarees, his battered straw hat, his eyes full of stars and flowers and flesh, and the hand, his hand. . . . The good life holds him in its green rosy circle, in its sunny embrace; unheeded flies zoom about his head like tiny planes waiting their turn to land, and from the comfy kitchen of the rugged old house issues a blue-aproned someone bearing a cup of wine or is it milk (depending on the age of the artist).

The coffee-table books are full of them: The Artist in His

Studio, the soaring sky-windowed studio which he has caused to be built, or the loft he has found, the barn he has remodeled, with north light; the photogenic studio that contains his future triumphs and past failures, his dedication and his doubts filling the air like bubbles in the perfect light that falls on the often empty canvas with a blinding crash of reproach.

Several days have left their gestural arabesques in the big room, adding up to clutter and despond. Dust has been raised in the lens of your eye; intention has softened to vagary.

Then an idea in the night brings its baggage to the morning. Welcome! Go ahead. Stare at the canvas already occupied by wrong paint, hangdog. Then a dive made at last with an intake of breath having nothing to do with self-preservation.

Now the doors are all open, the air is mother-of-pearl, and you know the way to tame a tiger. It will not elude you today for you have grabbed a brush, you have dipped it almost at random, so high is your rage, into the amalgam of color, formless on a docile palette.

As you drag lines like ropes across one brink of reality after another, annihilating the world you made yesterday and hated today, a new world heaves into sight. Again the event progresses without benefit of hours.

Before the emerging picture there is no longer panic to shake heart and hand, only a buzzing in your ears to mark rather unconvincingly the passage of time. You sit or stand, numb in either case, or step backward, bumping as often as not into forgotten objects dropped on the floor. You coax the picture out of its cage along with personae, essences, its fatidic suggestion, its insolence. Friend or enemy? Tinged with reference as black as an address book, weighted as the drop of rain that slid on the window, it swims toward completion. Evening soaks in unnoticed until penumbrae have caressed every surface in the room, every hair on your head, and every shape in your painted picture.

The application of color to a support, something to talk about when it's all over, now holds you in thrall. The act is your accomplice. So are the tools, beakers, bottles, knives, glues, solubles, insolubles, tubes, plasters, cans; there is no end. . . .

Time to sit down. Time to clean the brushes, now become a

kindly interlude. Time to gaze and gaze; you can't get enough of it because you are now on the outside looking in. You are merely the visitor, grandly invited: "Step in."

"Oh I accept." Even though the twilight has faded to black and blur, making sooty phantoms of your new companions, you accept. Feeling rather than seeing, you share exuberance. You are surprised and uneasy when you seem to hear the rather conspiratorial reminder that it was, after all, your hand, your will, your turmoil that has produced it all, this brand new event in a very old world.

Thus you may think: Have I brought a little order out of chaos? Or have I merely added to the general confusion? Either way a mutation has taken place. You have not painted in a vacuum. You have been bold, working for change. To over-turn values. The whirling thought: change the world. It directs the artist's daily act. Yes, modesty forbids saying it. But say it secretly. You risk nothing.

This last additional touch with the light failing and when you thought you had done with it; you so believe what you have done when you have not done it at all: it has simply *pulled away*, detached itself from you like the ineffable division of a cell. You watch its final separation in the fading day with a nod of recognition for you see that the sixth sense has been dealt with.

What is to be made of this, O analyzers?

What can I tell you, O gentle art lovers, O kindly dreamers? Is some help needed? Doesn't the paint say it all? What am I after? A long time ago I said I want to seduce by means of imperceptible passages from one reality to another. The viewer is caught in a net from which he can extricate himself only by going through the whole picture until he comes to the exit. My dearest wish: to make a trap with no exit at all either for him or for me.

XI *Chiaroscuro by Day and by Night*

Lying in bed too long gives rise to sometimes mediocre thinking, untrustworthy feelings, even misapplied musings such as the kind of fractioned attention I have been giving in far too equal measure to the writing of this piece and to my half-finished picture in the studio. Especially when recalling those violent hesitations, mountain-top, lake-bottom searches in the slippery psyche when I opted for the life of a painter. You would think that had settled it. So it did. Like everyone, I balanced, chose: doctor-lawyer-merchant-chief, all lackluster titles it seemed then, if you held them alongside artist-poet-dancer-actor-tightrope walker, slated to fall on one side or the other. Although that too is a beggarly comparison, inaccurate. I want to suggest trembling youth with all the world waiting for you alone.

No need to hide anymore behind the painted answer. No need to hesitate. God knows there are plenty of doors ajar for us all. Enter! Enter I did—the painted door. Could I push the written one? It always struck me as too dangerous. It is still dangerous. Ah, this is where I should have put that tightrope, anachronism that it is, up there with just two ways to fall. Two siren songs. And this is noteworthy, central as the Great Divide: on one side I saw only voluptuous magic, constant explosion of possibility, stunning prodigies to be achieved in states of swoon and euphoria. On the other side was a labyrinth of wily, shifting, seductive, powerful, razzle-dazzle words that would either elude and mock me like a comical clown or wrap me up in other people's *trouvailles* like the used mink coat from the thrift shop.

It would have been so unbearable to fail, even once. It would have killed me. Words are cutthroat, I thought then. They pretended innocence, deviously danced and postured around me, but I wasn't so dumb. I knew they could blud-

geon, and that they were often joyless. Paintings can fail but all is not lost. Failed painters survive rather happily. They have such a good time doing it and in the end can hide the thing in the closet before the doorbell rings. Some of these blossom out in the street shows. "The beggars are displaying their wounds," says my cruel friend Wes.

With words you are expected to be a realist. Now who wants that? A daily, hourly battle to escape reality with its stern demand for consistency is what takes up my time. Back in Galesburg one talked about something called split personality. An affliction to be dealt with. How many times one worried about possibly having it, like shingles, and now, reckless, how daringly you acknowledged it—why, what luck to have two personalities instead of only one! So that your Hyde may rampage in brutal phrases, your Jekyll dutifully watches his syntax and never throws in a word without first looking it up and stamping its passport.

Woman by the way is happily doted with two personalities, the outside one and the inside one. She is the fire at the earth's center. But for some that isn't enough.

Reading in Nabokov that "nature expects any full-grown man to accept the two black voids, fore and aft, as stolidly as he accepts the extraordinary visions in between," I understand that I am "man" and I appreciate the phrase as being applied to myself. "We" found the word *man*. We also found the word *brontosaurus*. And *woman*. A refinement? Double talk?

Meanwhile the letters keep coming. A sea wave, The Movement washes over me, an unwary beachcomber; it pulls, drags, coerces, demands my solidarity, my *admission* of sisterhood. Looming large in my corner is the phenomenon of Women Painters. This category of endeavor, painting, has somehow captured the hearts of numerous champions of the cause. There seems to exist among them a belief that if women can paint they can do anything. People who never bothered with pictures before are now organizing woman-exhibitions in every corner of the land as well as in foreign climes. They are feverish. They are scholarly. The exhibitions are catalogued, documented, prefaced. Superbly undaunted by the shortage

of quality material, they make up for it with long historico-analytical hyperbole about shadowy feminine painters of the shadowy past. If I fail to answer their letters they write again. They love to argue. Some even get nasty and bawl me out in what I sense is a state of hysteria (thus proving their femininity). One of these organizers, writing from Italy, suggested that possibly my reluctance to participate in the exhibition was based on shame, that perhaps I didn't have anything good enough and that I need not be afraid to admit it.

I do admit that I have enjoyed answering some of these letters. They bring out the worst in me. "A medical examination," I said once, "should be a condition for inclusion—above all today when imposture is so rife that a woman exhibitor could turn out to be only a man." Things like that.

So, though I feel a little something, it isn't enough. It seems so clear: nothing to be done short of revamping the whole human race. Not only useless, I am an enemy in absentia. Blacklisted by clique and claque.

But there they are, these pictures that have no place in our biological morass, our mouse fate. Instead they are pirate maps, diagrams for mutiny. Compasses for farther regions. My never-never land? If you will.

Another reason for shunning words—and there is nothing faint-hearted about this one—I wasn't sure I wanted to reveal myself, crazy, sly, erratic, excessive, hopeless me, to give up the rag of mystery that, with careful ironing and frequent mending, had covered me so far. Writers are so transparent, I told myself. They tell it all. They become callous. There is not a corner of their soul where they don't rummage without mercy, snorkelers wrenching out private hunks of coral to serve up in some written context or other. A real self-rape. When they walk into a room you know *all* about them, the public persons, the transparent authors. You remember certain nuggets: fact or fiction? You think, ah, that one. Like identifying a species of goldfish pushing around in its bowl with the others, gay little strings of syllables dangling from their bellies.

The trouble is, the bowl is too small, the water is polluted and, worst of all, I seem to have joined the swimmers. A bad

dream even though it is only a short one. Because I was just getting around to the overwhelming final reason: emotivity.

The fact is, a mere word can break my heart. So that a lot of them, dredged up from my own tender self, day after day, would destroy me. Deplorable? Not really.

In a life defined by dearth, my ever-ready tears have provided opulence of a very superior kind. Whatever joys I may have longed for, surely none could have approached in conferment of sheer transport the shedding of tears. Abundant feeling, in fact, drowned the most acute privations, rendering forbidden goodies damply spurious and dim.

Over the years knowing so many who could not weep, I have come to appreciate my thirst for sorrowing, or at least to view it with calm. Too, for one who overflows with everything but words, it has been the very true expression of my abiding, my utterly crushing sense of doom.

For a while I kept a diary, trying to put it all down, showing thereby some sort of resistance and even vaguely hoping that my pen would, in recording the components of the equation, penetrate its mystery. But it didn't do anything of the sort. A quite shattering experiment, it merely aggravated the sorrow and riled up the ooze at the bottom of my own familiar, beloved, impenetrable, shivering abyss.

Along with abstract grief I nourished the conviction that nothing good ever happened to me that would not have to be paid for in some harsh way sooner or later. Except when I was with Max, who succeeded for a while in making me believe that this was not true. And that an inflexible unknown would not calculate and collect my debts. (Dust under the rug.)

So now it was spring again, and for three years I had been adjusting more or less to a condition that would be permanent: that of a solitary person. Brittle as glass and unshatterproof as an egg, I trod with caution. Don't look back if you don't want to be turned into something else. Because my identity seemed all I had left and this too was shaky.

Alone you like to think you are on top of your situation, you now contain your loss without cracking up, and you have arranged your space and your time; an *estropié*, your wound has

healed and you will meet any exigency. But you can so easily become ridiculous; a breeze here, a gust there can topple you. Long years of trial in one column, error in the other, with small successes to spur you on in the pursuit of fearlessness. Not to mention a certain charming area of feeling that includes brief swaths of being kind to others, like holding your breath under water.

You lay aside ardor, hope and other impedimenta; you deliberately drift, never mad or sad or glad enough to spurn the mainstream. You wake early, think of yourself tenderly, more than less serene as you face the hoodlum parade of half-hours laden with half-hearted minutes already wilting under their load of gratuity. Even so they tease you on, not into anything final—would I want it?—but only into the studio where those millions of choices lie. Grains of sand in the desert. Whirl of dust outside the window. Shaping up, imitating persons, tapping. Open the window. I knew you would come.

I knew you would come, milord—isn't that what they called you, Churlton, and dressed you up in velvet and plumes to camouflage your evil charm, your gashed mouth, your luxurious guilt? If you are here to tell me what I am, forget it. For you are nobody. Once you came, an urgent dream, swashing and trampling on my chest. You promised me the moon and the sun and gave neither. Now you are a scarecrow, an obscure monad, a smudge under my paintbrush which is the end of my hand. And I lift it away from the canvas in the nick of time to save your face from crumpling.

Which brings me to Eros, the companion invariably assigned to me by the experts who are always ready with explanation, a kindness in a way, to tell me what I am painting, what is leaking out from under my fingers, all unconsciously. He, the god, is known to be blindfolded. We are both blindfolded, everyone is blindfolded, stumbling, groping, doomed. The fancy well-washed machine we use, its parts called upon to mesh impeccably, *as is proper*, according to its powers and its limits; the machine admired, polished, enjoyed for its elegance, more or less loved. But heavy, watery, a little foolish, running to keep up. There is wanton waste of hours to gain minutes. Perfect diagrams of rites having to do with skin,

eyes, hair, secretions and excretions are drawn up and scrupulously observed.

Oddest of all, the sad little procession of analyzers, trudging toward the altar of libido, singing their quavering hymns from the open books of Sigmund Sang Froid (Max's pun). For example, some paintings of mine that I had believed to be a testimony to the premise that we are waging a desperate battle with unknown forces, are in reality dainty feminine fantasies bristling with sex symbols. Elsewhere, two rows of terrible teeth on one of my sculptures become, under these gimlet eyes, incredibly, a vulva. A statue that I thought was a moment of grace is a male sex, this doubtless because it is standing up instead of lying down (O vanity). Death's face, which I fear, looks out at me from many of my pictures. But it is often mistaken by these hot-blooded writers for the face of lubricity. Though they can spot Eros every time, they see no one else. Who is hung up here, the artist or the viewer? Meanwhile there is the private daily amazement, which is still mine.

It is Sunday morning, Sunday quiet. A truce of noise down in the street floats up like noise itself. I have brought my tray to bed, an old habit. Soon, from the other side of this wall come the screams and groans of my love-making neighbor. Full of energy and fury, they reach me and my tray just barely. Three years ago, the first time I heard her, and the second and the third, my ears fairly burned. I ate my toast slowly while listening to her in wonder and jumbled thoughts, realizing that I had never screamed like that and wondering if love was even more delicious *chez* my neighbor than what I had always known it to be. High silky screams. Of course. I knew about that. But it is not the same, just knowing. Here they were right in my own ears, making me guilty willy-nilly of voyeurism. Lying in my bed I am motionless, all is motionless, only my blood moves, doing its thing with discretion, keeping me warm and comfortable.

During the years that I have shared this wall with her and growing used to their punctuality (ten-thirty or eleven Sunday morning and sometimes Saturday too), I have anticipated these strident, urgent sounds. They have even become a

source of all's-right-with-the-world satisfaction to me until now, so accustomed am I and so hardened to the music of her transports that it is no more noticeable than a clock striking the stupid hour. Moreover, I will drop her soon in a change of abode. Goodbye Eros. Goodbye dear neighbor with your strenuous, thrashing, sweating screams, your hard-won ecstasy achieved in a city tower. We leave you on the dissecting table, a tidbit for the hordes of hungry analyzers, while we depart for a last visit to ourselves.

At age seven and eleven, sure that I could have it all, to be an artist was a welcome command. Even with what it implied of square-peg apartness, of wait, watch, work, wonder. Of patience. And, furnished with plenty of fervor, I saw no problems. It all went together so beautifully. If Lord Churlton did not come to Galesburg, the world amply made up for him later. And to replace my box of pallid watercolors, a multitude of means have pitched in to help realize that stirring imperative that possessed me then.

Everyone has their demon, I thought. Even the handsome self-assured girl, aged fifteen perhaps, who at some school performance—this in spite of intervening years is unforgettable—pronounced that the mills of the gods grind slowly. It was an ineluctable fact graven on the stones of the planet, the way she said it. As far as I am concerned the words belong to her; no one can tell me she did not invent them that day. Of course they do grind exceeding small, those mills, because she ordained it with her fine demonic diction and her fraught voice which at fifteen was the voice of fate.

My demon, or demons were twins, for going away from there made the command double, the need for physical distance that had nothing to do with that faraway dot on my perspective lesson but only with a way to see that should be mine. Go, I said, go forth. Find the round world.

So, first, watercolors shared my eyes with maps, in those days of the 1930s a busy pastel geography where boundaries slithered and disappeared as fast as chess pieces in a whirlwind game—built-in obsolescence of nations, states, dukedoms, regions, with their tiny kings and tinier armies. If I was to see

Montenegro, "a mere chaos of mountains," area 3,255 square meters, or meet King Zog in Albania, I had better hurry before both vanished. How could I ever get to Hunza?

At least that one childhood resolve—I would be an artist and live in Paris, France—was realized. Of what avail? Half a lifetime is hardly enough for such multifaceted discovery. Paris, a dazzling friend. I never really got to know her, years and years just always on the edge. Perhaps she wore too many pearls that added nothing, really nothing to the ensemble and only brought out the pallor of her afternoons.

The most beautiful city in the world, I said, and mine. Its arrogance, its garbage, its waistline. But the arrogance was cautionary: Do not rock my secrets. If you must touch me don't probe. My tunnels are locked, my byways lead backward, my slate roof shelters French poets and carbon monoxide is my hard heart.

There are still times when the thought of distant and various unknown places cannot be contemplated without a clot of suffocation. The certainty that I will leave one day, having known so little of place, so few campsites; the unbearable thought that I may have been in the wrong rooms, that another front door, back wood, side street held revelations I never dreamed of. Even as I ride on a train or bus with houses streaming past, it never fails to possess me, this queer longing: how would it be to live behind those two windows, with someone coming home at night? It is essential to know this, how it would be, how I would be.

Not that my familiar spaces are unfurnished. Consider the eventful mirrors, the talking phone, the cozy materials of my craft, the microcosm involving my own tool drawer with its tangled string and orphaned keys. I muse on the roof garden opposite where apologetic little wisps of "trees" sit in rationed earth and concrete tubs, bending to city wind. Who is not charmed by trees on a roof? Knowing that their days are rationed too. They will not grow great and old but will live briefly as those pale doomed girls lying on sofas, barely able to lift a transparent finger in the whispered gesture of farewell.

An artist is still a Giotto hermit alone in the desert. Re-

moved from the world as he is, the bustle in the distant town
(visible in the background), all the kaleidoscope of collective
turbulence affect him not at all, he confidently believes with
all his heart and soul that it doesn't count, that his desert suf-
fices when inhabited by his own dedicated self. Then, of a
sudden the sky lights up to flare its message: the world does
count, some.

We leave enigmas lying around, signs to be read ranging
from knife-edge to nebulae—pleas for guesses. Having posed
our riddle we hide behind a tree or a gallery wall and wait for a
sign. Even a firefly radiance. We have time enough but we wait
rather anxiously for a pair of eyes, any eyes, to flash pulsations
to a mind, any mind that will take us on with our visual
propositions.

Meanwhile we plan, tomorrow and next year and next sum-
mer. Late reflections ripen, late leaves redden, and uptown a
lecturer will speak on "Finding Worth in Human Beings." Of
course he will find it. He would not have chosen us otherwise.

Assessed, interpreted, pigeonholed, our riddles are in truth
consigned to the cold star of solitude—the painter's oldest pal.
You have gotten used to it like an infirmity, an extra toe, a jag-
ged scar, a smashed ear. You cover it up, and after a while you
can even forget about it for long periods, that is, if you have
had your share of shouting and dancing naked.

Ardent ringer of doorbells, hungry for other people's memo-
ries, an interviewer will eat up my afternoon. What can I say
that will end on an upbeat? He thaws me, he draws me out.
But why tell him that at twenty-four, choosing a life full of
mentors, I rarely ever again shared thought or deed with any-
one of my own generation much less of my very own age? It
was like skipping grades. Everything around me was colored
by attitudes of seriousness based on the weight of experience
and erudition. I persuaded myself to adopt them. It was a
privilege: benefiting from the already tried, from superior
knowledge. Safe from storms. Wanted, too, and needed, cared
for. There was room to turn around, room to dance when no

one was looking, room to do, to paint, to play, and no limit on solitary thoughts. It seemed enough, it *was* enough.

Only excitement slowed as the years went by. Quieted. My poets no longer raised their voices in dithyramb and diatribe but sat at copious lunch tables with uncrumpled napkins on their laps, reminiscing about their pasts and deploring the immediate one (ennobled elsewhere), in comfortable voices. Nostalgic they were and not unsatisfied with their violent histories. But all had become ordered, the lunch table swam in harmony, we were splendid. It could have gone on; it should have gone on if they had not begun to disappear, imperceptibly, like the nimble flash of the trap door.

At first it grieved me. A betrayal, shocking, a *supercherie*. How unimaginative to retire from combat, to hide, to disintegrate, to take leave of their senses; above all, to die and leave me in accumulating dust.

Here with the interviewer who has become a shape merely, a dubious presence, I am teased by unspoken questions, and chastened by answers that I try on like glass slippers that don't fit. There is no use telling him about my hours at the typewriter. It would only confuse. And I would have to say that as these pages piled up it became clearer and clearer to me that I had undertaken something impossible; that no matter how intensely certain moments came back to me transformed as memories, they were still only moments. I would never manage to make them represent one life, much less two, even by multiplying them a hundred, a thousand times. And the more I try for some defining picture of my absolutely incomparable life, with its passages from ignorance to revealment, its opposite poles, its complexities, banalities, terrors, euphorias, the more I see that I am not going to bring any order out of its confusions or authenticate its wavering pictures.

A wedge of late-day sunshine lies on the floorboards between our two chairs. Yellow ocher bright as paint, so far from the faded hues of Tzara's rainbow carpet, far from pearly Paris, far from all those gardens in diverse climes, spaces, soils. Twenty-four Parma violets, planted in red earth, in Sedona, and neatly eaten by morning. Tall corn cross-pollinates with lustful frenzy in Touraine. And Seillans is infested by

homeless cats that feed on our chickens, unfazed and amused by their flapping human pursuer.

You can laugh at the past, you cannot laugh at the future, I think. So I look out at that tree in the tub. It is waving to me from its roof.